BIRDS ARE PEOPLE, TOO

Humor in the Avian World

KATE DAVIS

2016

MOUNTAIN PRESS PUBLISHING COMPANY

MISSOULA, MONTANA

Library of Congress Cataloging-in-Publication Data

Names: Davis, Kate, 1959- photographer.
Title: Birds are people, too : humor in the avian world / Kate Davis.
Description: Missoula, Montana : Mountain Press Publishing Company, 2016.
Identifiers: LCCN 2016017664 | ISBN 9780878426690 (pbk. : alk. paper)
Subjects: LCSH: Photography of birds. | Birds—Humor.
Classification: LCC TR729.B5 D38 2016 | DDC 778.9/328—dc23
LC record available at https://lccn.loc.gov/2016017664

PRINTED IN THE UNITED STATES

MP Mountain Press
PUBLISHING COMPANY
P.O. Box 2399 • Missoula, MT 59806 • 406-728-1900
800-234-5308 • info@mtnpress.com
www.mountain-press.com

*Special thanks to
the birds in my yard and vicinity
for being so cooperative*

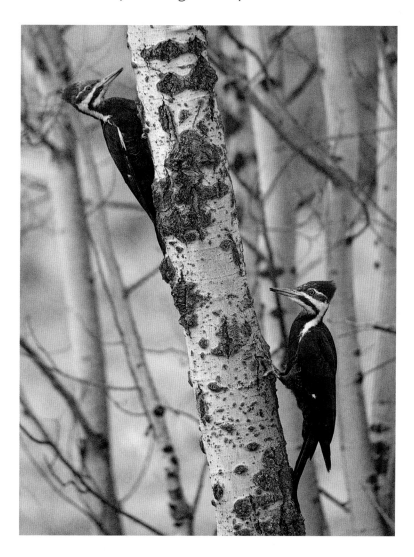

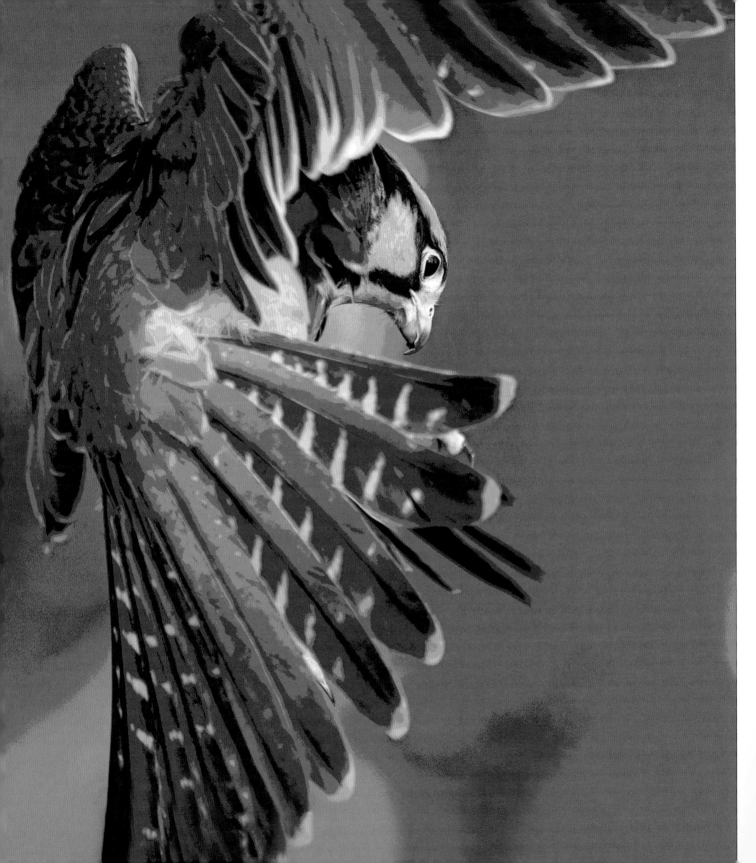

BIRDS ARE PEOPLE, TOO

Ever since I was a kid in the olden days when cameras still used film, photography has been my great passion. I've always been "shooting" animals thanks to my dad and his Nikon cameras and darkroom in the basement. Plus, I always had great subjects on hand—orphaned baby raccoons, foxes, kestrels, and owls that I raised with the Cincinnati Zoo's Junior Zoologists Club. We had a full house in the spring, and they were all released in the fall, their portraits in black-and-white covering my bedroom walls.

Digital photography changed everything, and I wasn't saying "thirty cents, thirty cents" every time I pressed the shutter. I started out slow with point-and-shoot cameras but moved up the digital ladder, illustrating my books on raptors. Captioning the photos has been a pleasure, writing brief and—hopefully—entertaining descriptions. So why not a book with a different slant? The idea was by my friend Cathy Scholtens, who suggested that I write the *funny* things the birds are saying, thinking, or doing—sort of imaginary avian subtitles.

My husband and I have a Bald Eagle nest just a six-minute walk from our house on the Bitterroot River in western Montana, and I can watch the young grow through a spotting scope in the living room. The last few years I have been obsessed with evening marches to the river with the tripod, camera, and dogs. It was there, standing for hours each night, that these captions popped into my head, written on little pads of paper jammed into the pockets of my vest. The eagle's fourth year of nesting was 2015, and three females fledged in late June. I had fun photographing these big dark birds chatting or chasing each other, interacting with the other beach inhabitants. Most of these photos in the book were actually taken in my yard or nearby. I've added some Peregrines and Snowy Owls from the Washington coast, and egrets and a duck from California.

Images are all of wild birds except for some shots of a Peregrine Falcon, Harris's Hawk, Aplomado Falcon, and Northern Saw-whet Owl—some of our beloved birds on the Raptors of the Rockies teaching team. I added descriptions of the photo circumstances and a little science in the Appendix.

The title comes from a saying I have when we are out doing Peregrine nesting surveys and we see a falcon streak across the sky. "Bummer! Prairie Falcon," which is the wrong species. I always reply, "Prairie Falcons are people, too!" And so are all birds, it turns out.

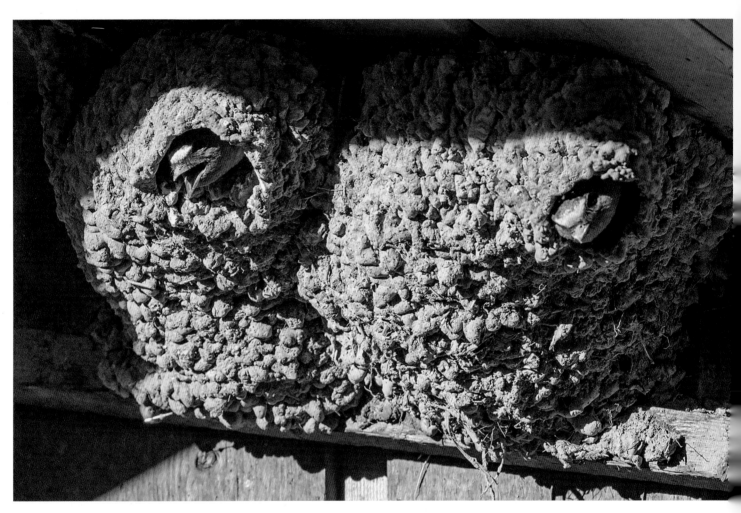

"Hey, I'm out of paper on this side. Do you mind?"

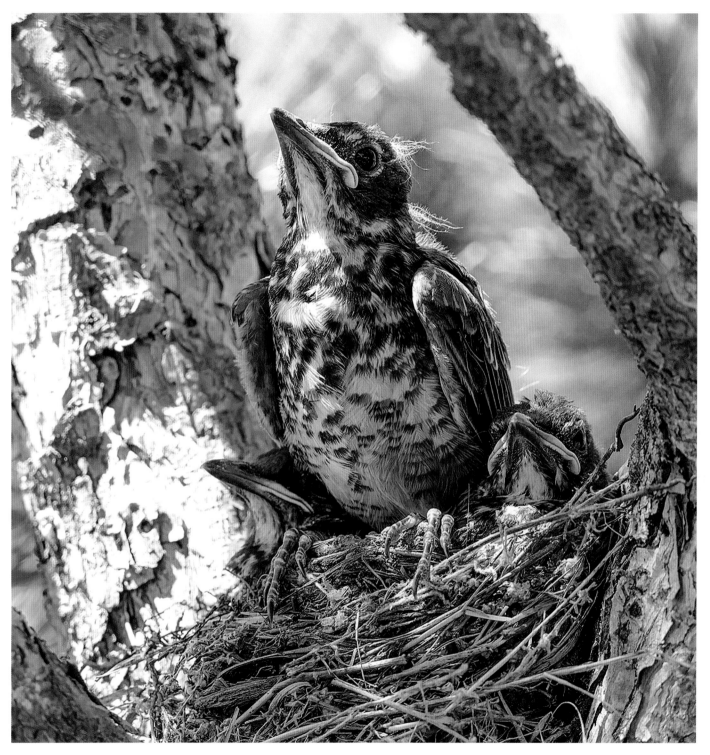

Jessi's younger brothers couldn't wait for her to leave for college so they could have her room.

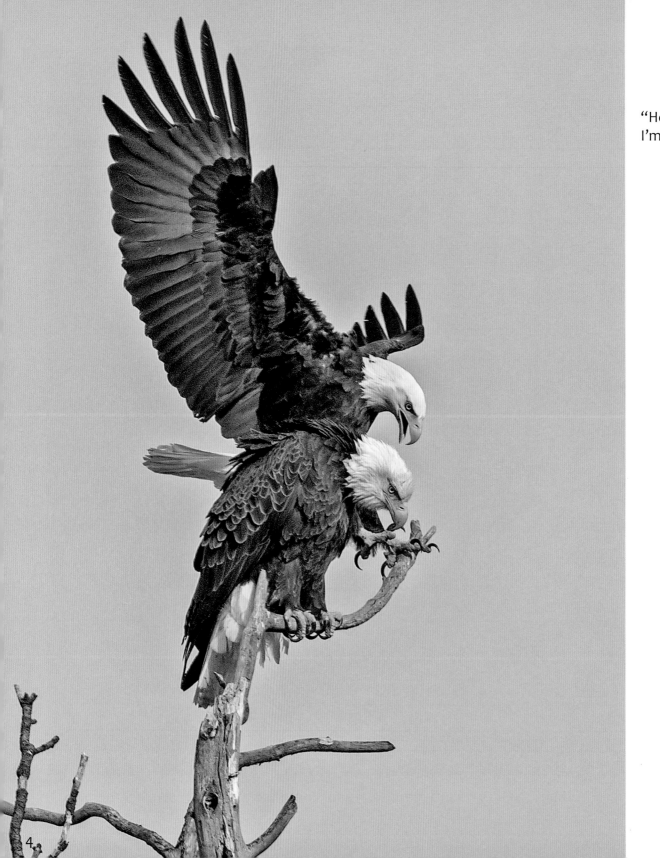

"Honey,
I'm home!"

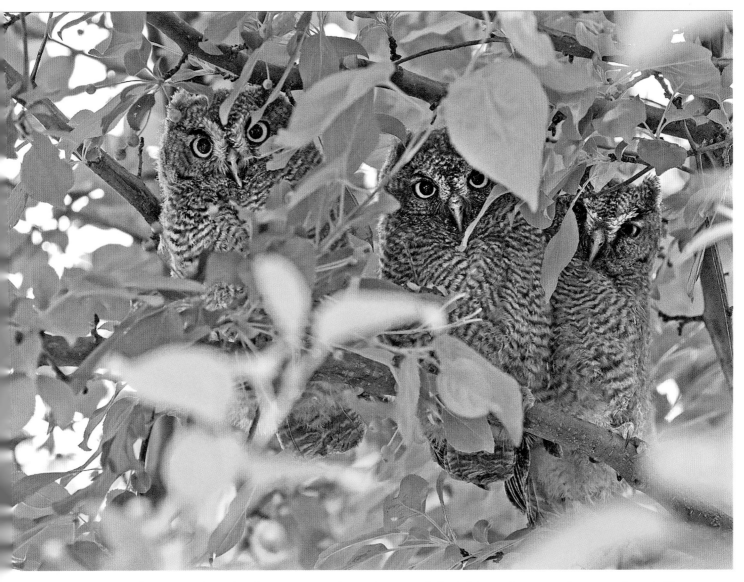

"Shhh! Don't move, they don't see us. Birdwatchers and their binoculars . . . give me a break."

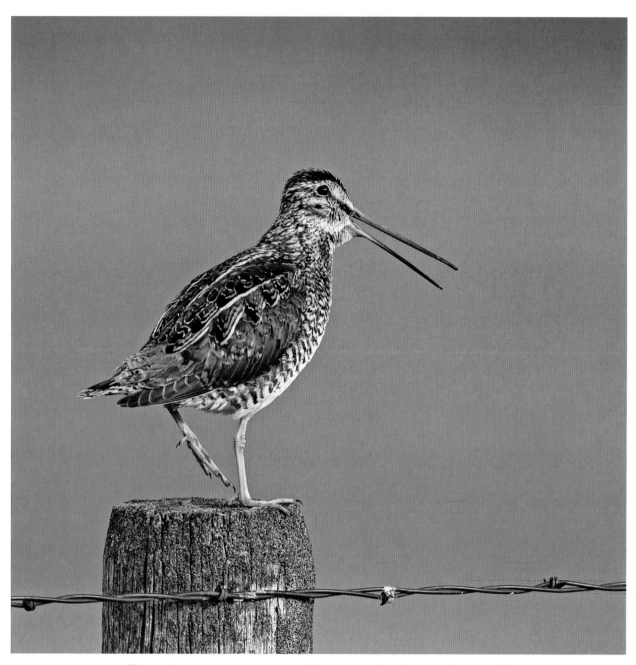

"Here I am, you campers with your sacks! Snipes do exist!"
Jack's brazen taunts would cost him dearly one day.

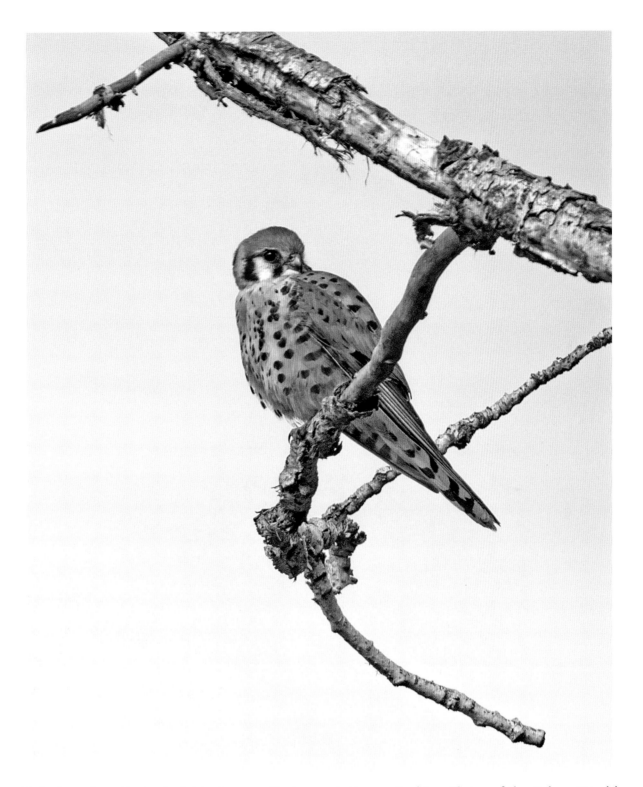

Male American Kestrels richly deserve their reputation as Fashion Plates of the Falcon World.

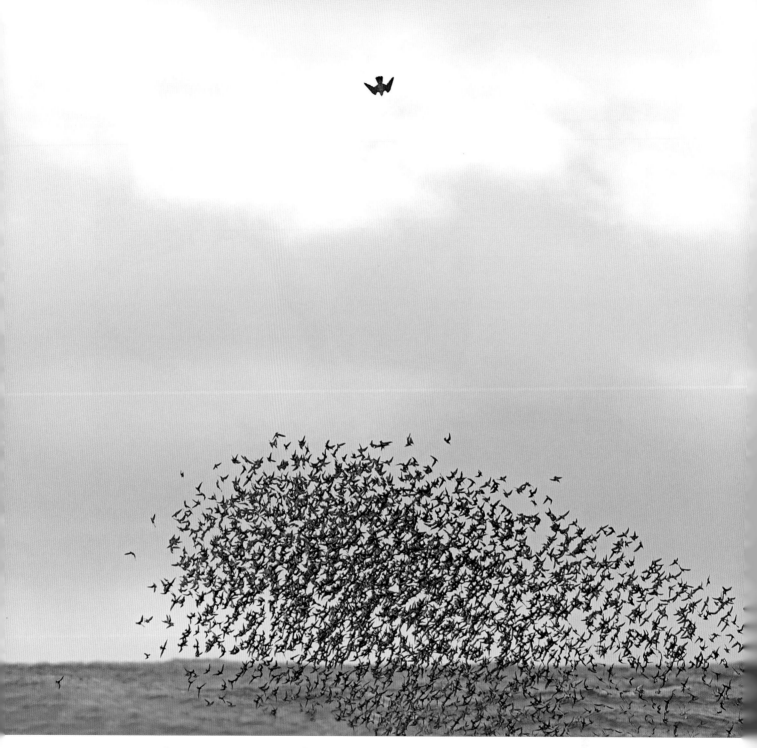

"Do you ever get the feeling that there is a greater power up above?"

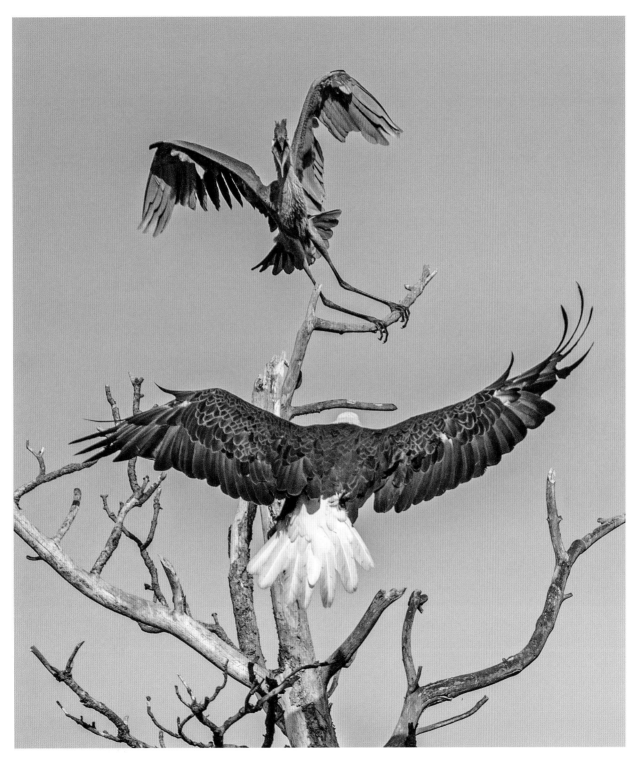

A reminder that your heralded top position as CEO may be overthrown by a hostile takeover at the drop of a hat.

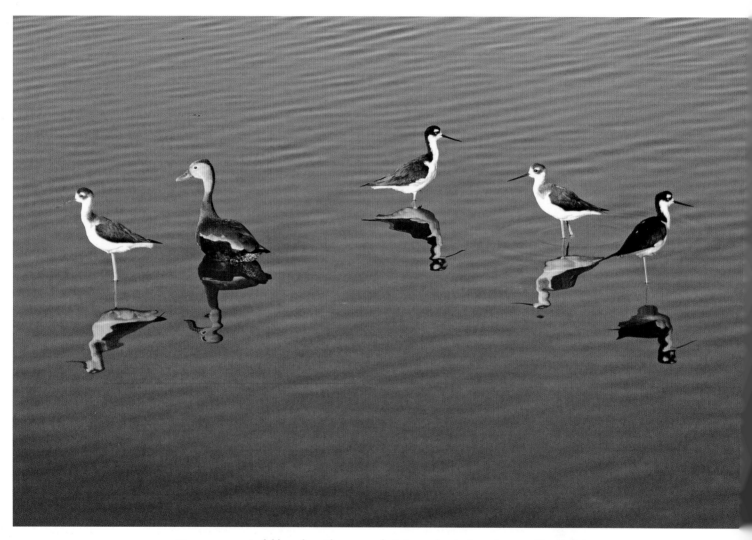

Nora never told her brothers and sisters, but she always thought she resembled Mr. Brown, the butcher at Safeway.

"Calm down. I'm sure that whole moving-out-and-getting-a-job thing is just a joke."

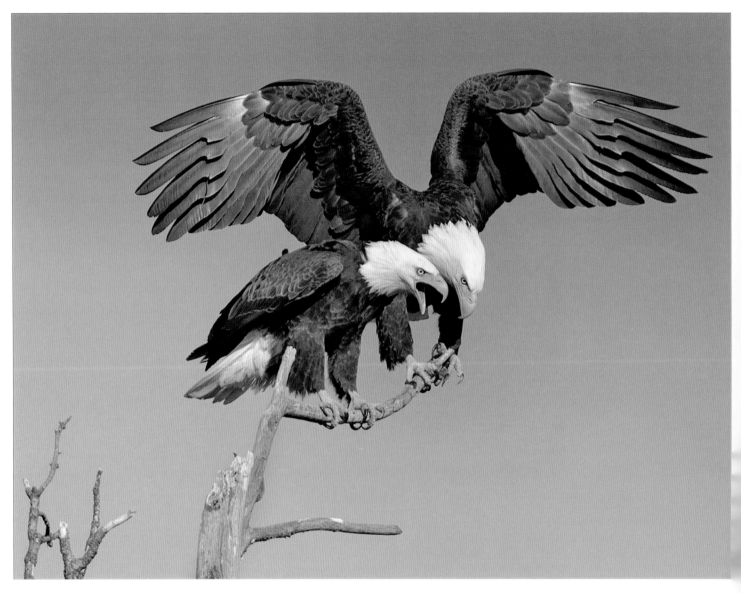

"I swear to you Bert and Alice get 200 channels. All we have to do is hook into their pole. "

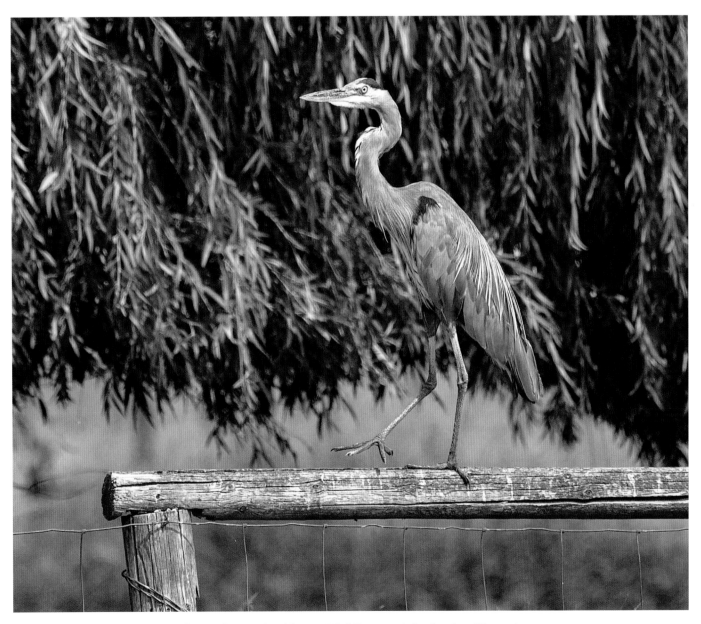

Balance beam had been Vicki's specialty in the Olympics.

With his fondness for water, Justin imagined in a previous life he may have been an otter. Or a lifeguard.

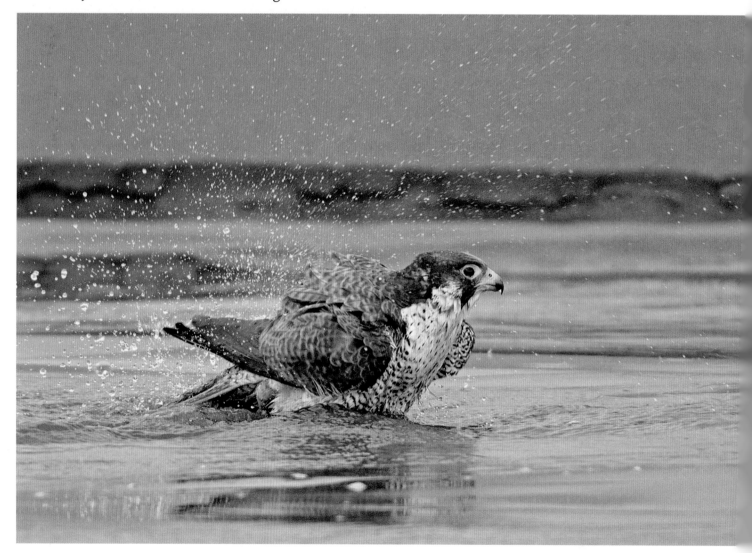

His daytime cover was blown. The stakeout was a failure, and Bud feared his days as a private detective were numbered.

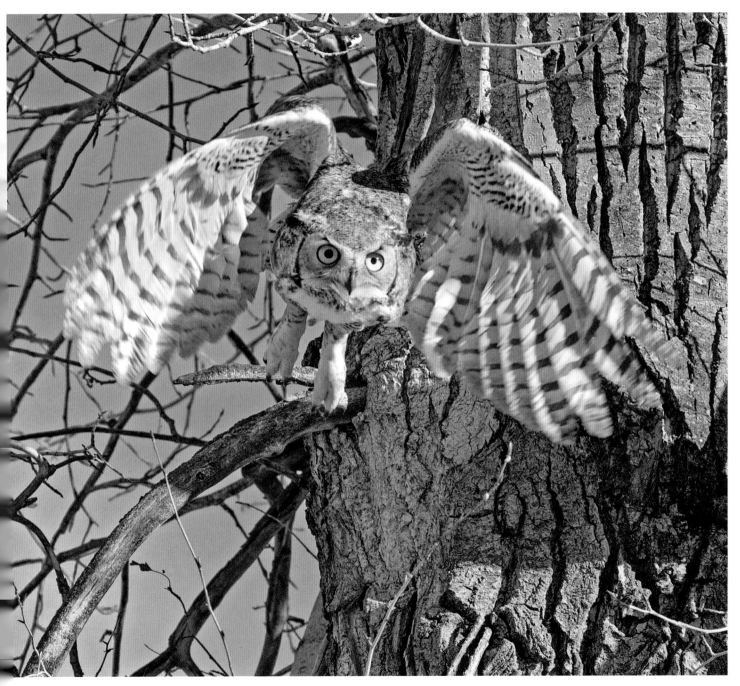

Carmine vaguely remembered seeing an advertisement for ready-made wooden nest boxes. If she had one, there would be none of this digging-out-tunnels-with-your-feet stuff.

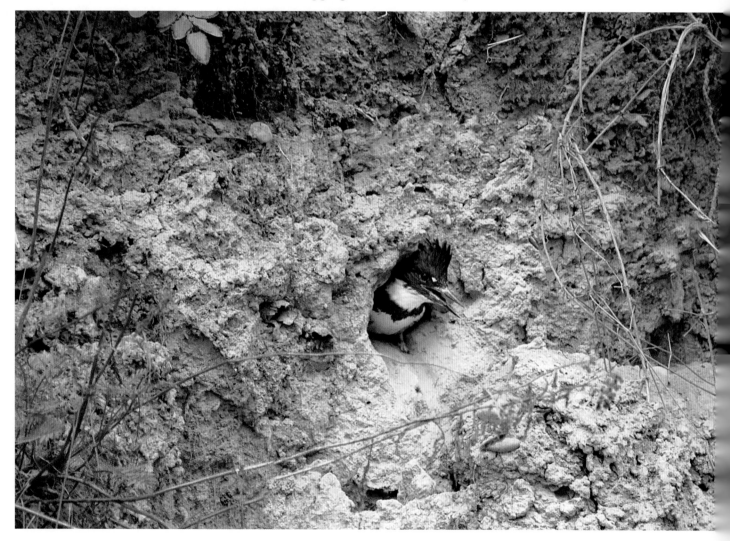

"Yard sale down the road. Man, they were practically giving it away!"

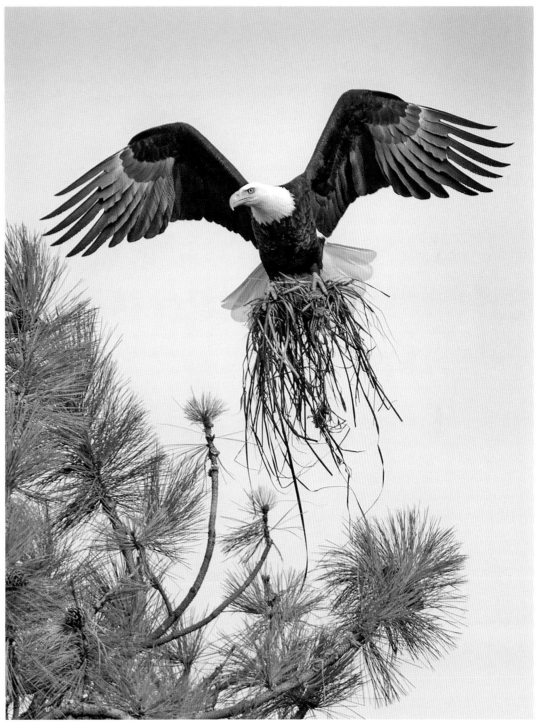

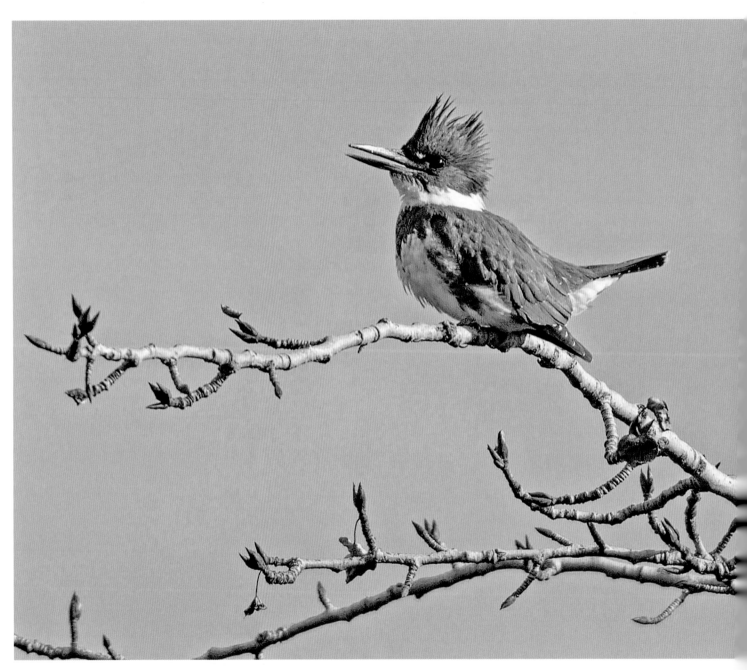

Phil thought it unfair that his wife was more colorful, so he changed his hairstyle and struck a manly pose over the river.

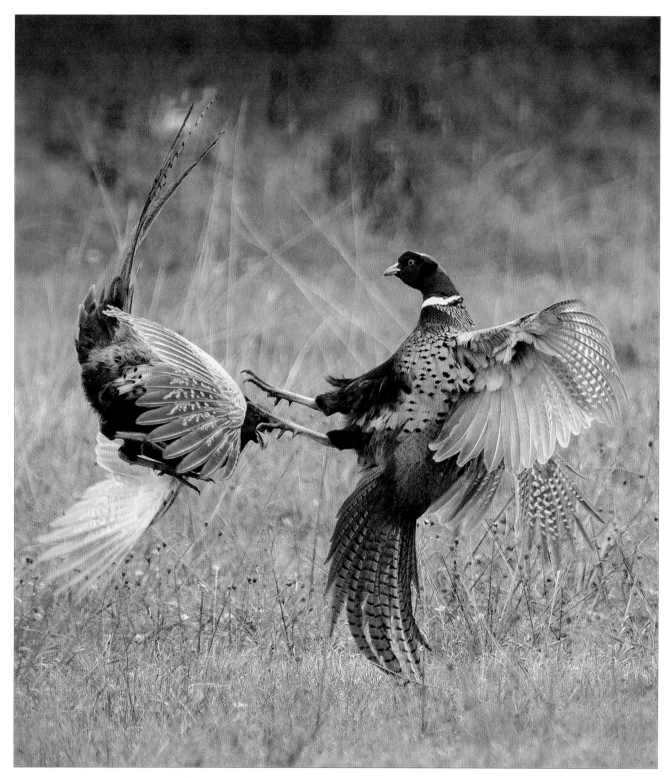

The blood sport of cockfighting is illegal but still practiced by a hearty subculture.

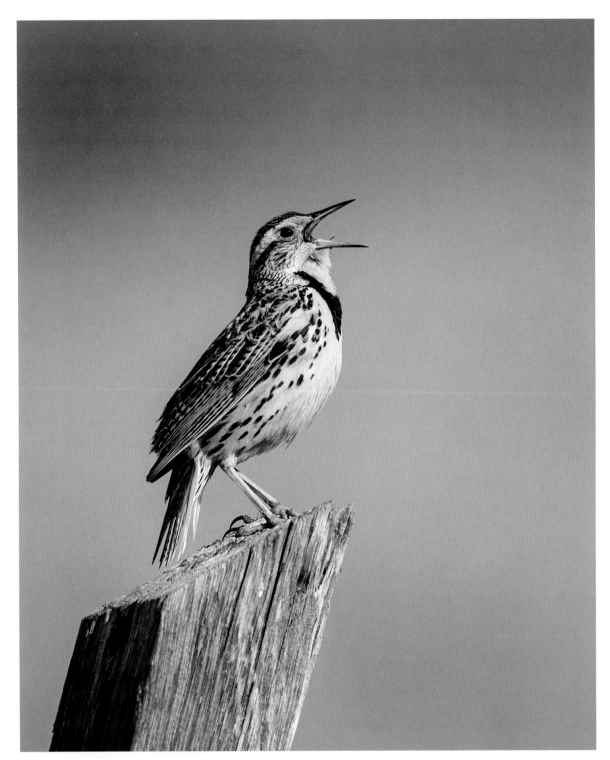

The Dawn Chorus of Songbirds was soon drowned
out by the Large Ensemble of Lawnmowers.

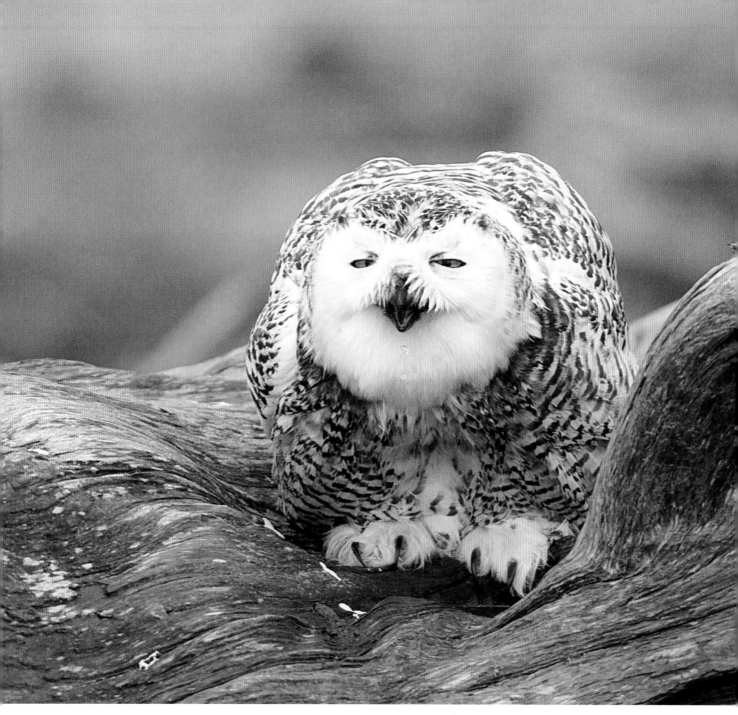

Wine tasting had always been Phyllis's specialty, but perhaps she overdid it with the Chateau de Root Wad.

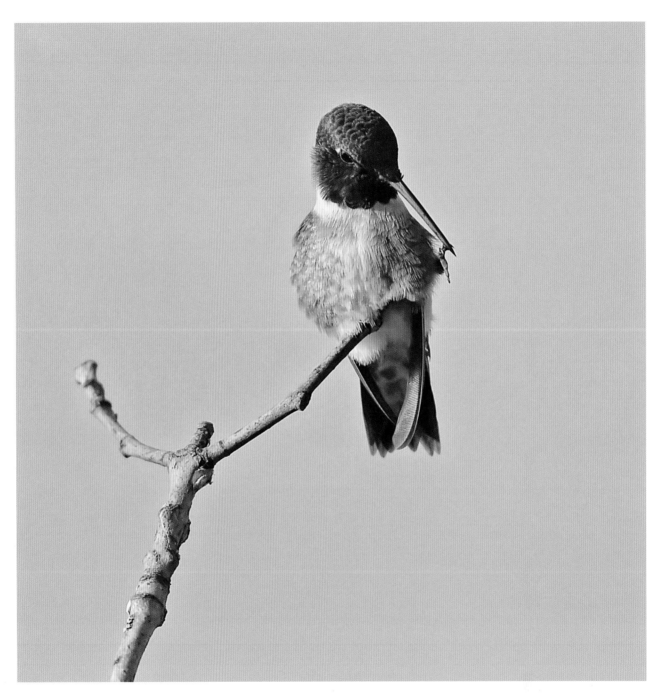

Attention to detail: that's what leads to promotion in the work place!

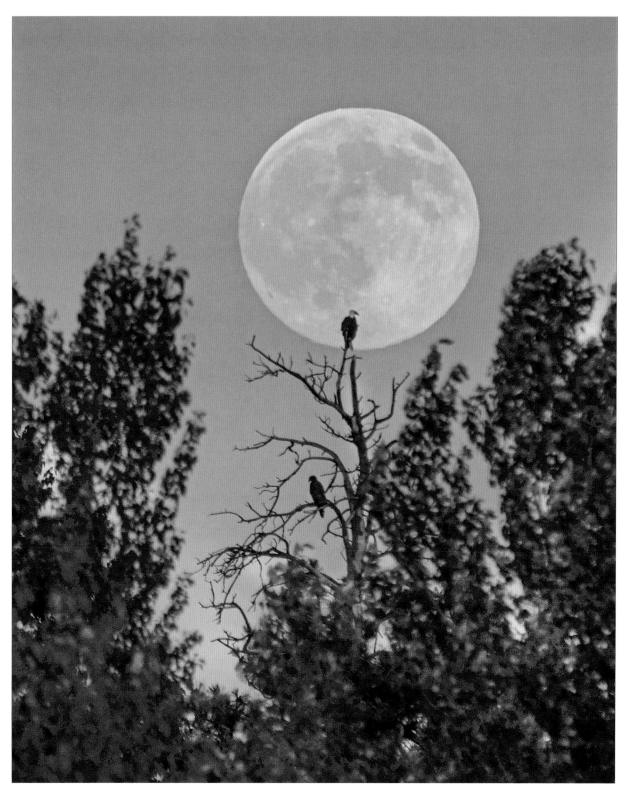

The supermoon of August only made the Aguilar family more deeply contemplate their insignificant place in the universe.

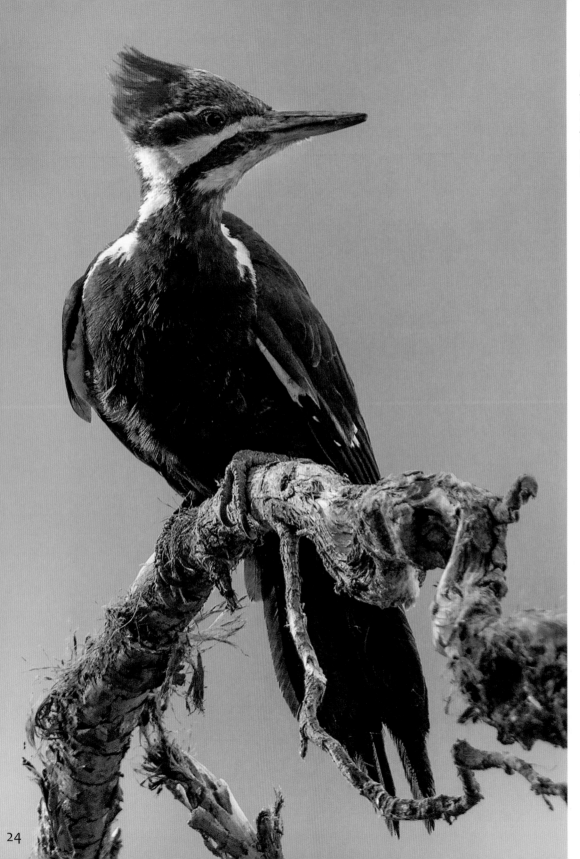

"Do you think these scapular feathers make my tail look fat?"

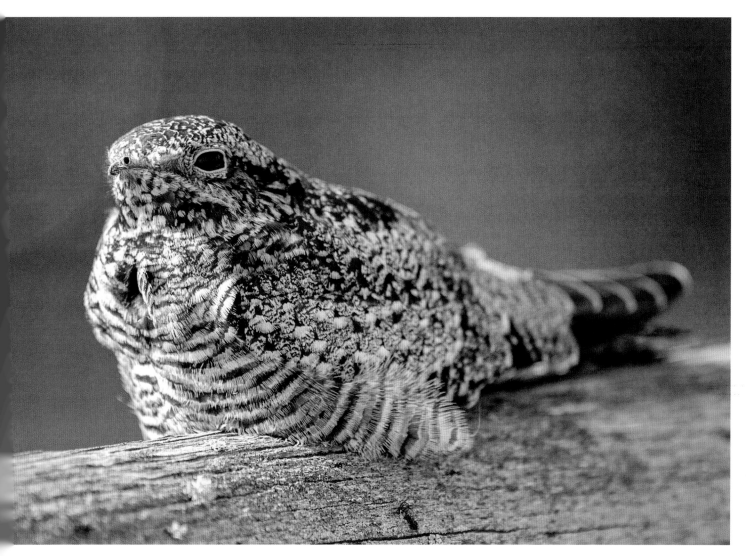

Gordon loved to pretend he was a lizard.

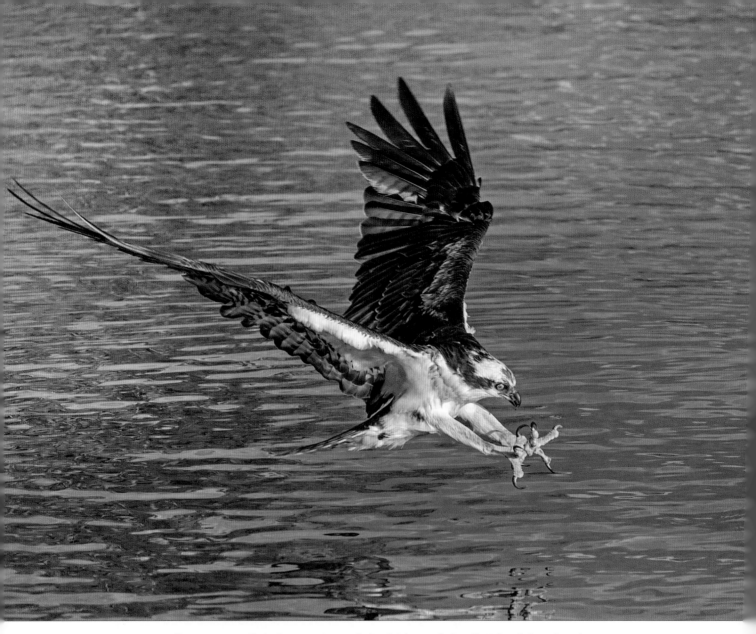

"One more fish for Rosie and the kids and I'm finished for the day.
Back to the pub to shoot some pool with the boys."

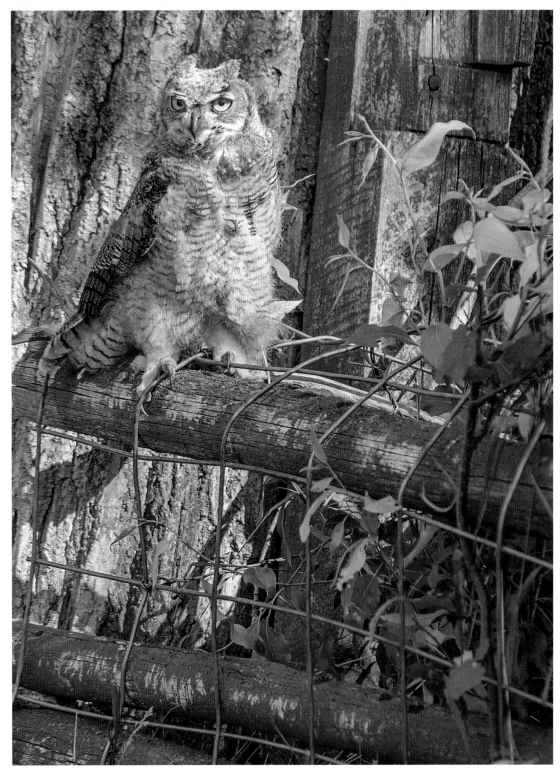

After coming up empty-handed all hunting season, Simon decided that Cabela's fall line of camouflage wear was a flop.

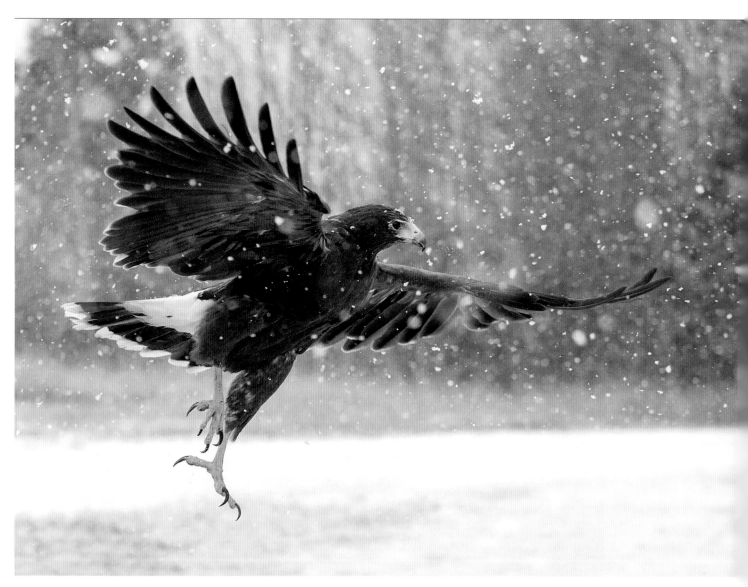

In spite of his desert heritage upbringing, Seth became quite an accomplished ice dancer.

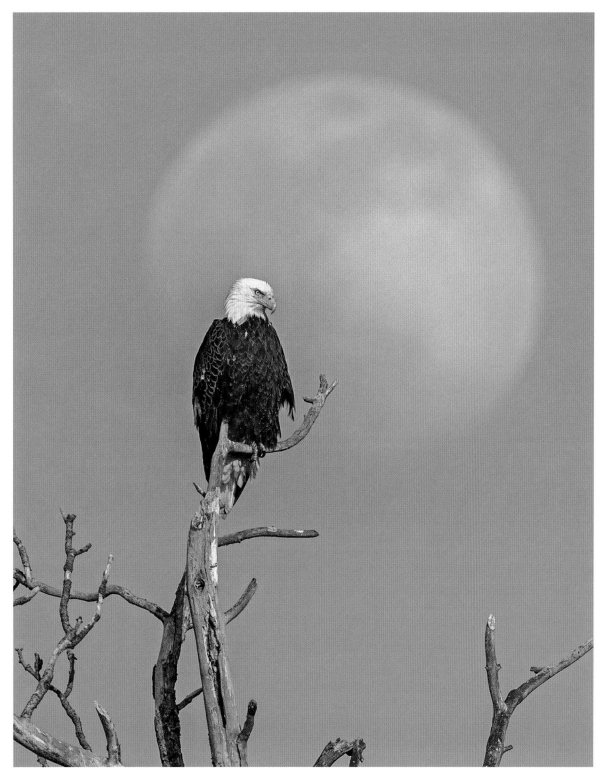

"Bald Eagle plus Full Moon. Add an American Flag and we'll go viral on Facebook."

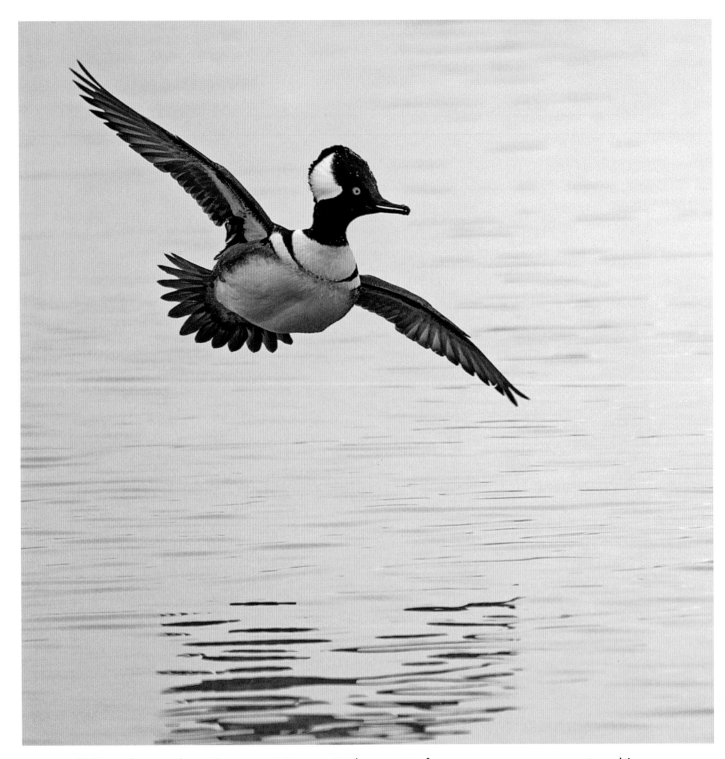

"Please locate the exits nearest to you. In the event of an emergency, your seat cushion may be used as a flotation device." Jeffrey was named Flight Attendant of the Year 2016.

"I'll split that with you," offered the kestrel. Russell chuckled. No way was he falling for that trick again.

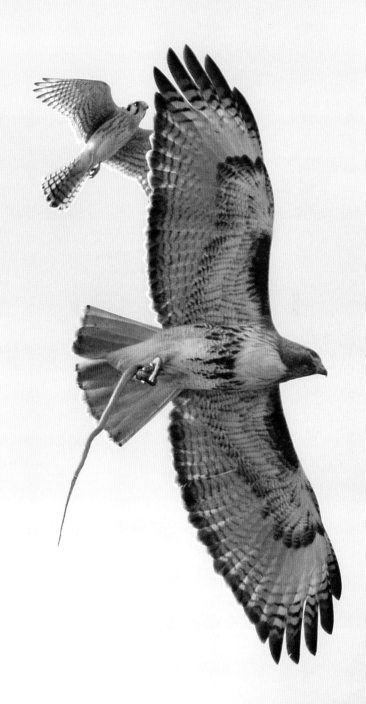

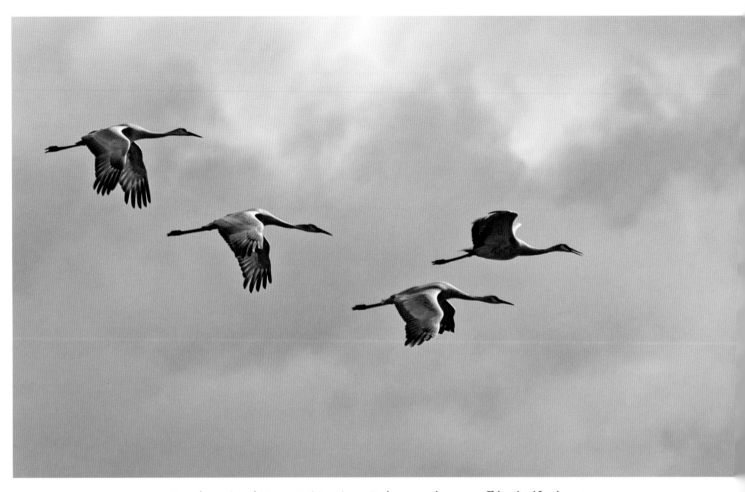

Synchronized Team Migration: Bob was always off by half a beat.

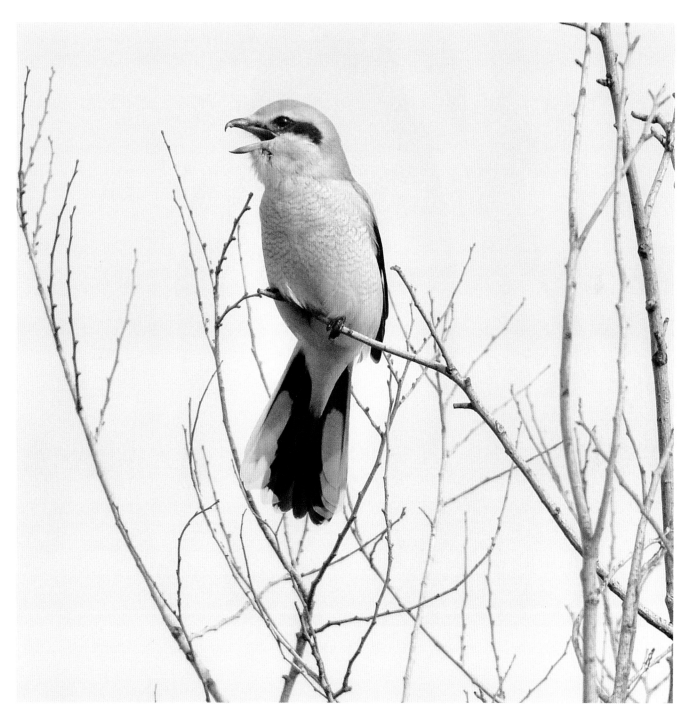

Tony gleefully sang "Death to songbirds," forgetting he was one himself.

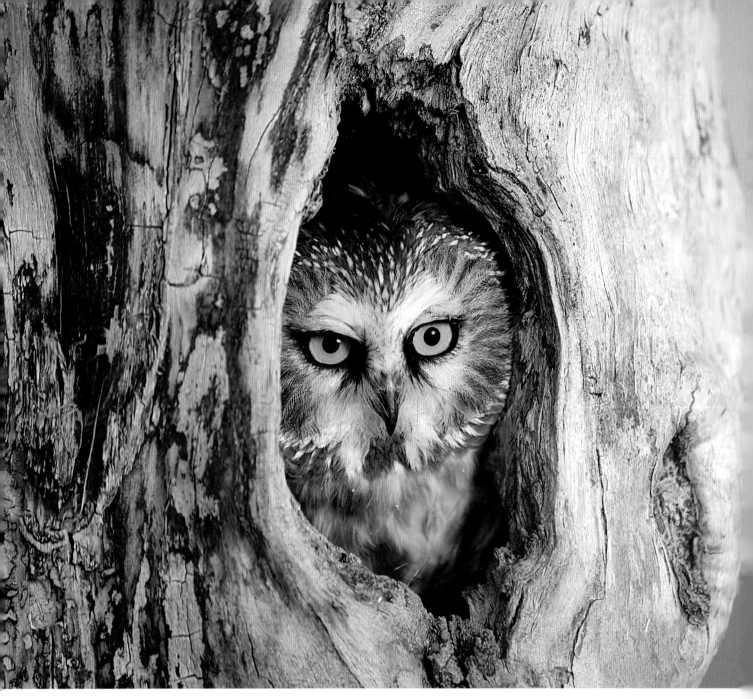

Everyone in the neighborhood was wary of Sheila, the local busybody and gossip who didn't miss a thing.

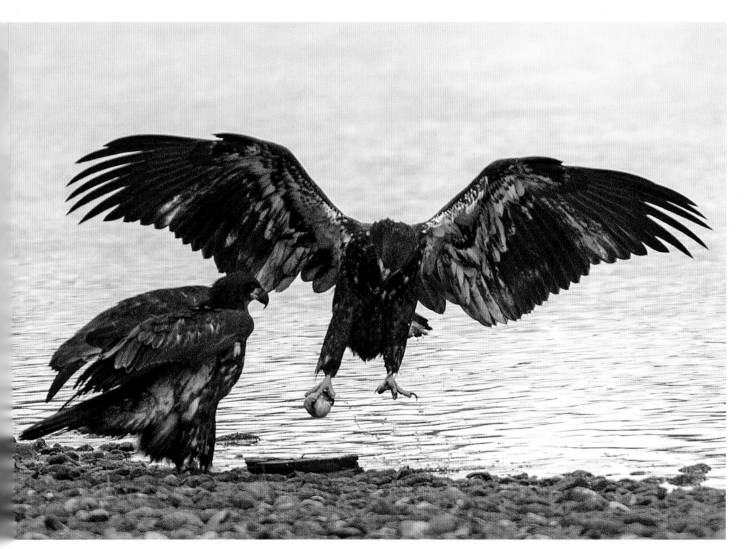

Tennis anyone?

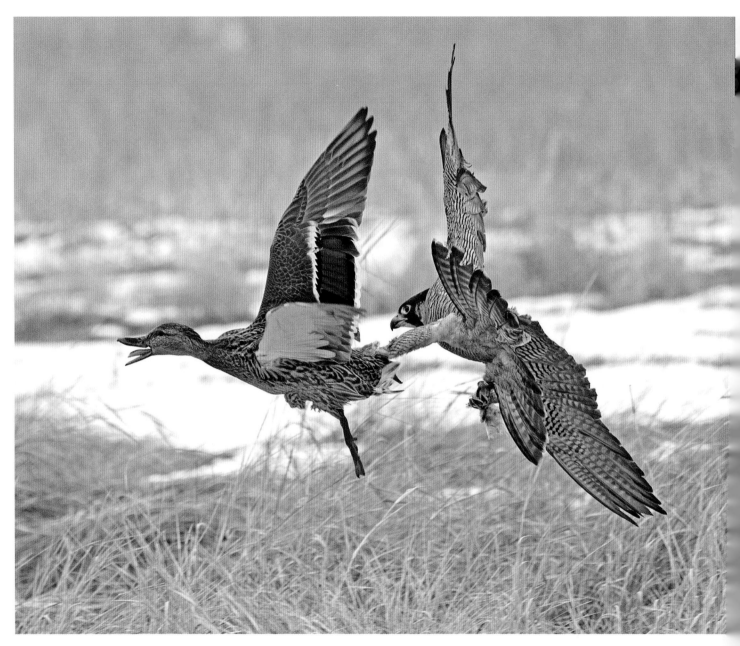

"Damn! This shortcut across the park will cost me some tail feathers."

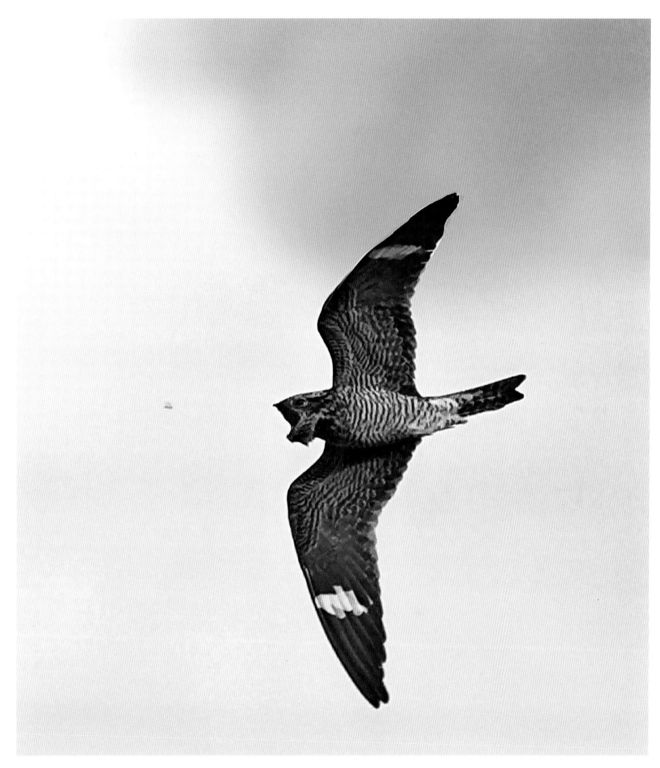

"There has got to be an easier way. Might be time to start ordering bugs in bulk on the internet."

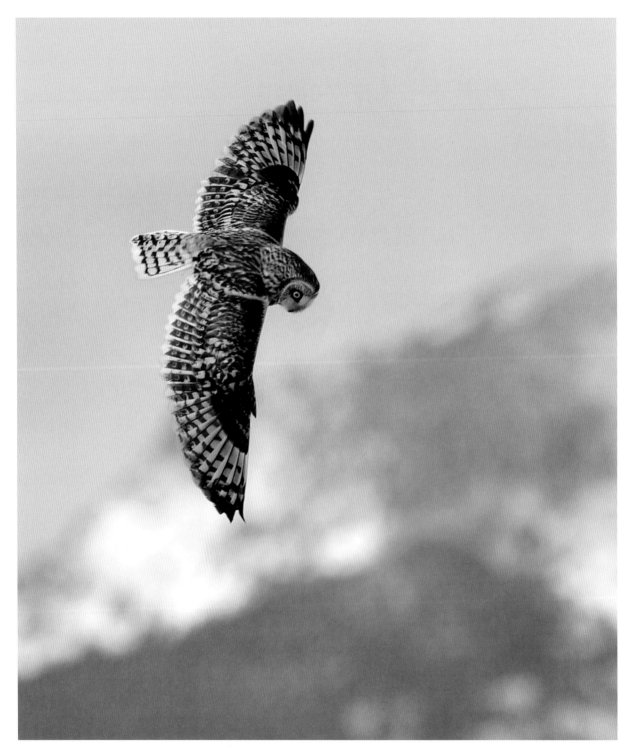

"Someday they'll have little flying cameras, and this surveillance business will be a thing of the past."

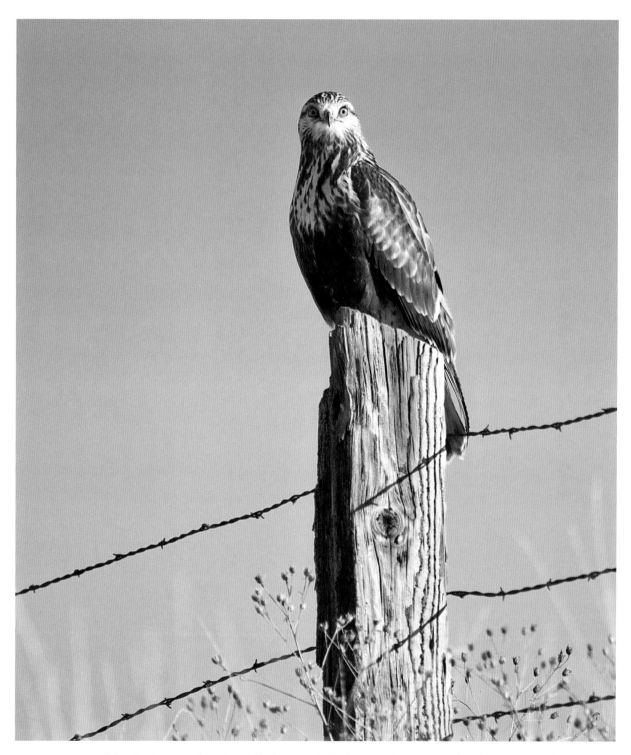

It suddenly dawned on her: "Oh no, I left the coffee pot on back in Alaska!"

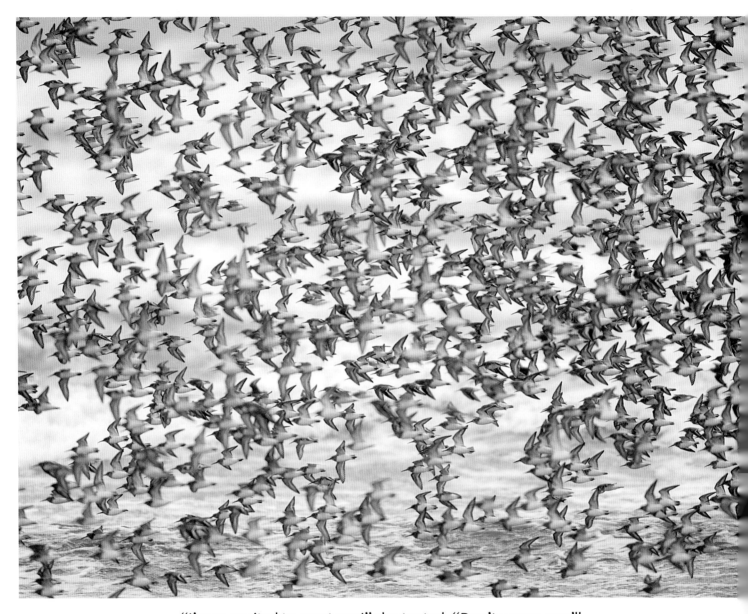

"I'm so excited to meet you!" she texted. "Don't worry, you'll recognize me—I'll be the one wearing the white scarf."

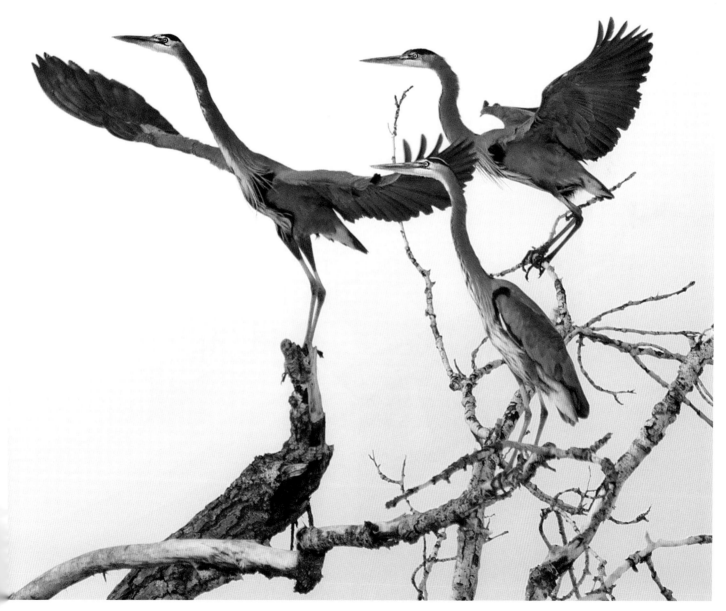

Last Call at the Tavern of Colossal Birds.

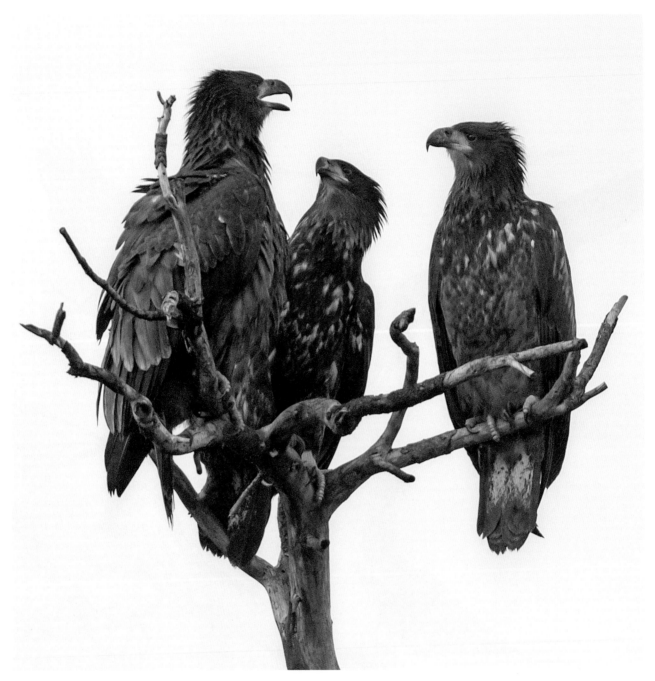

"I heard about this fresh roadkill on the highway. Plus I got the scoop on a bunch of dead fish downstream. Or we could just stand here and beg like we always do."

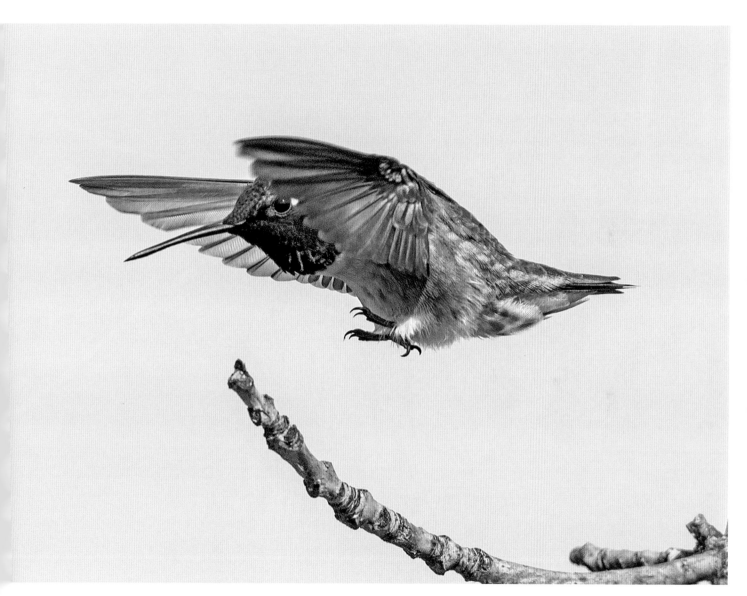

A pinpoint landing hits pay dirt for the hard-working team at Mission Control.

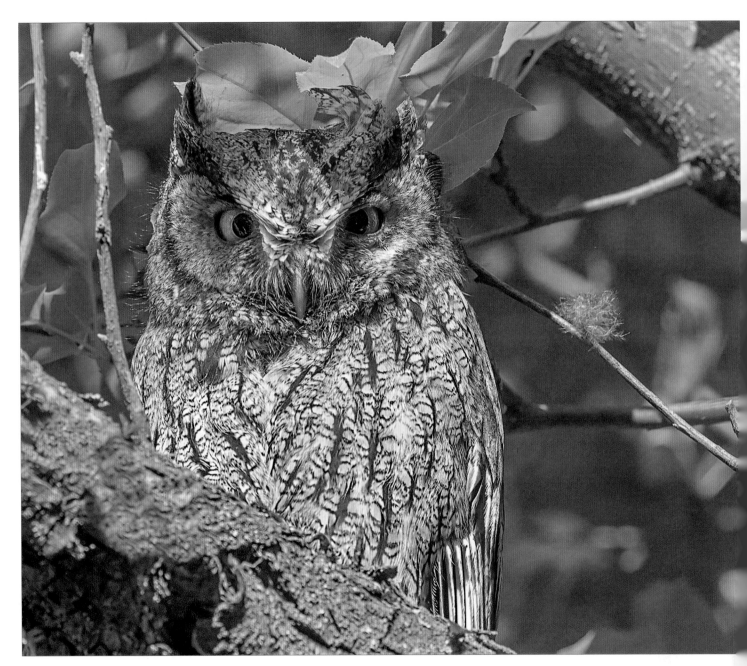

Not that wise, but pretty darn smart.

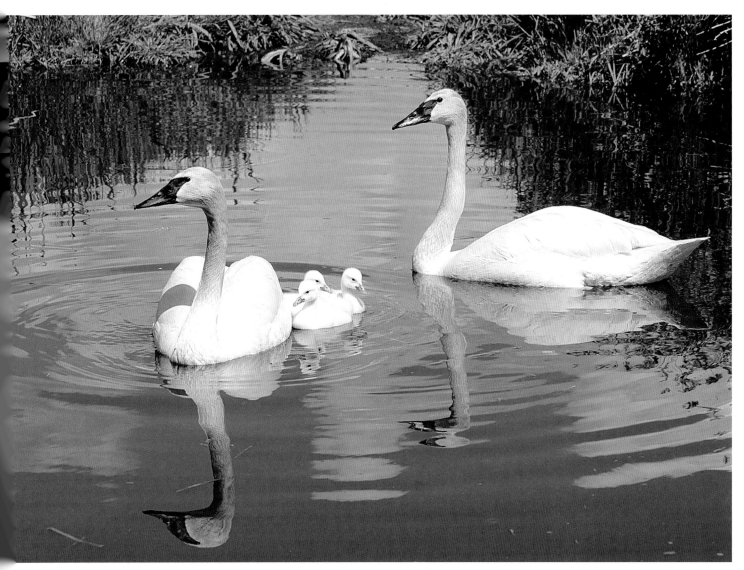

The Trumpeters had it all: money, looks, and three perfect children.
Yet Marge couldn't help but feel that something was missing.

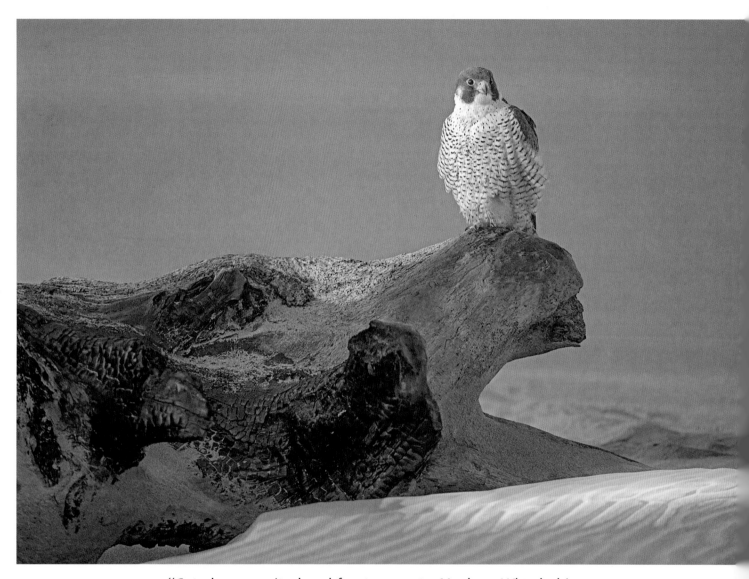

"Gated community, beachfront property, Meals on Wheels, bingo on Fridays. . . . The kids really nailed this one, bless their hearts."

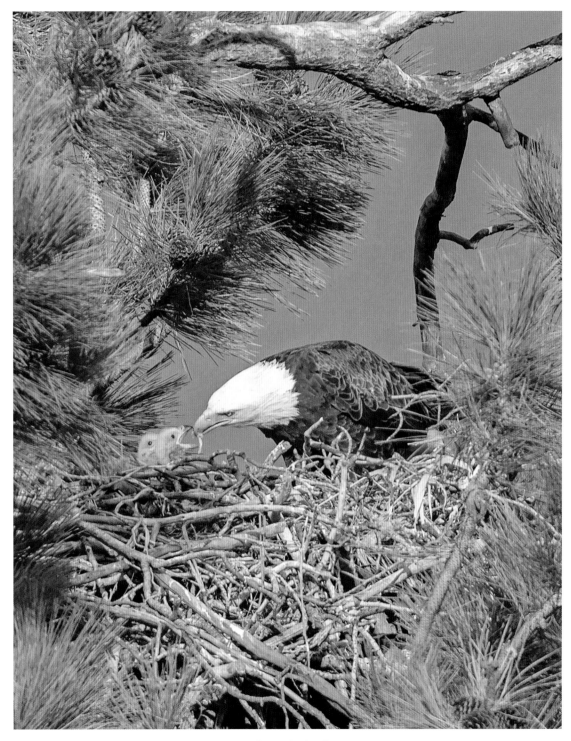

Fish and Chicks

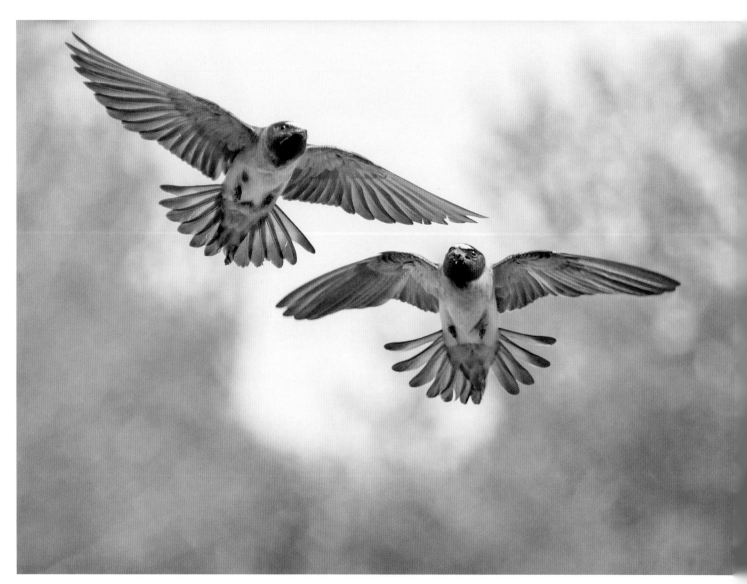

"Savor these carefree summertime romps, as they will just be happy memories during the long migration to Bolivia that begins next week."

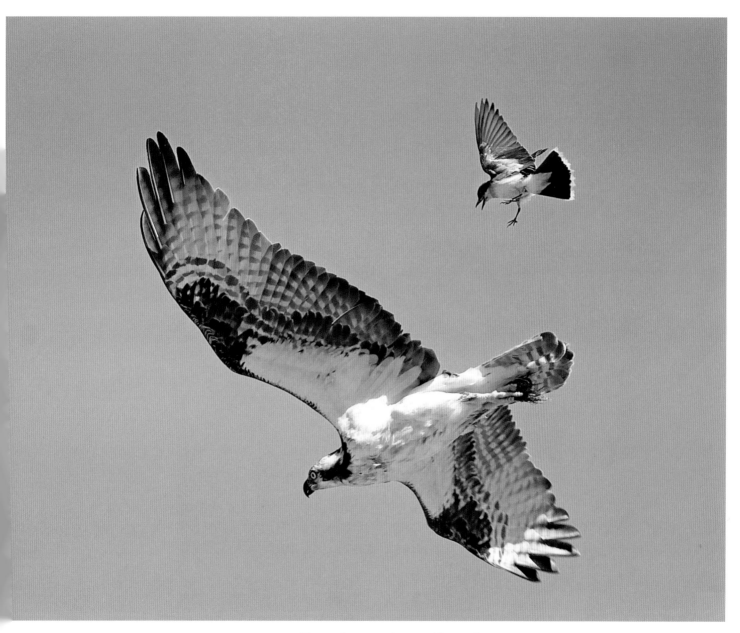

Commuter traffic is always plagued by tailgaters.

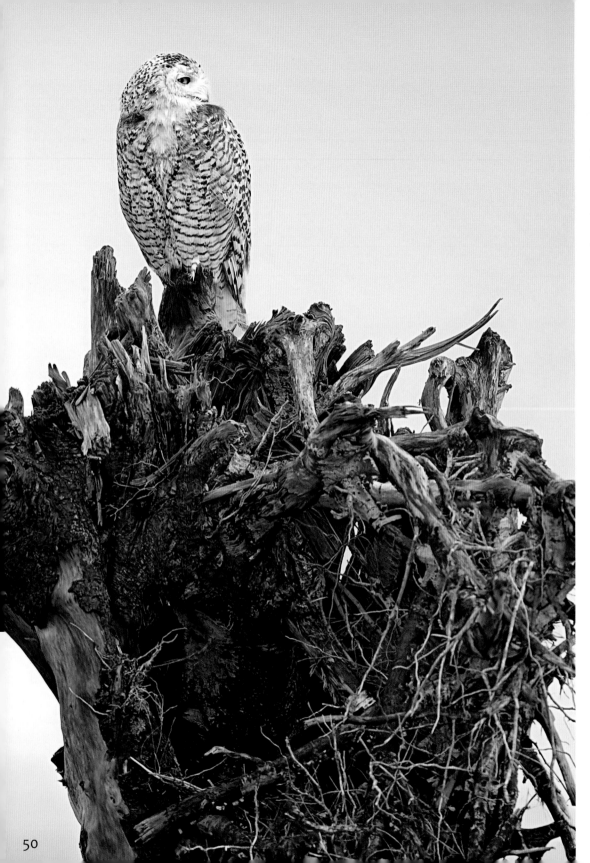

Between films Hedwig, the Snowy Owl, retreated to a bungalow in the sticks, a location unknown even to Harry Potter.

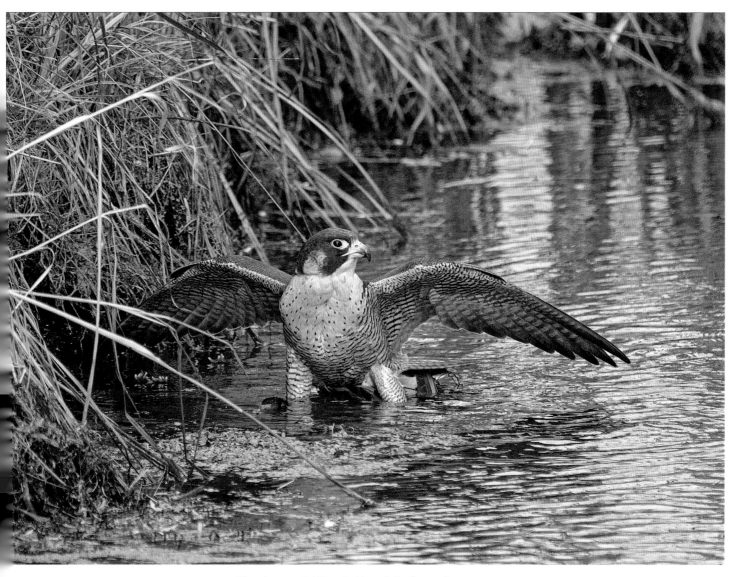

The intrepid Duck Hawk in her element.

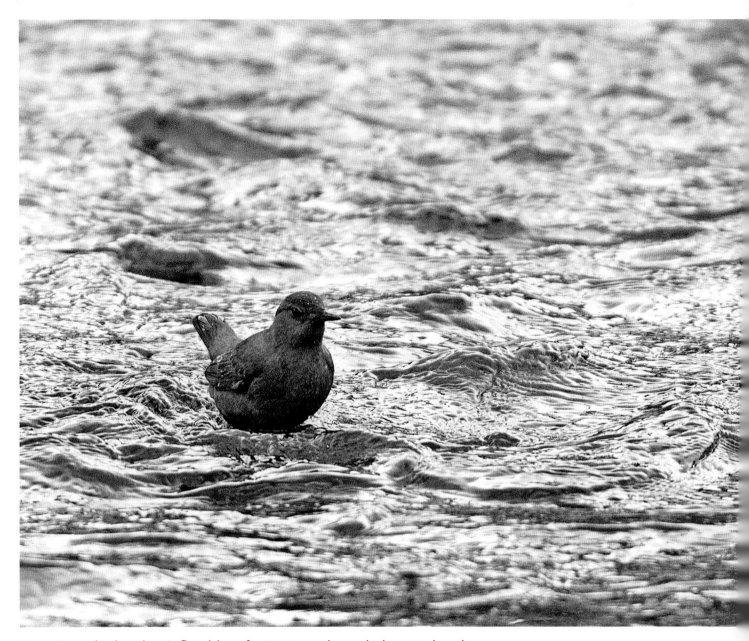

Ever since she lost her inflatable raft, Megan only waded out to her knees.

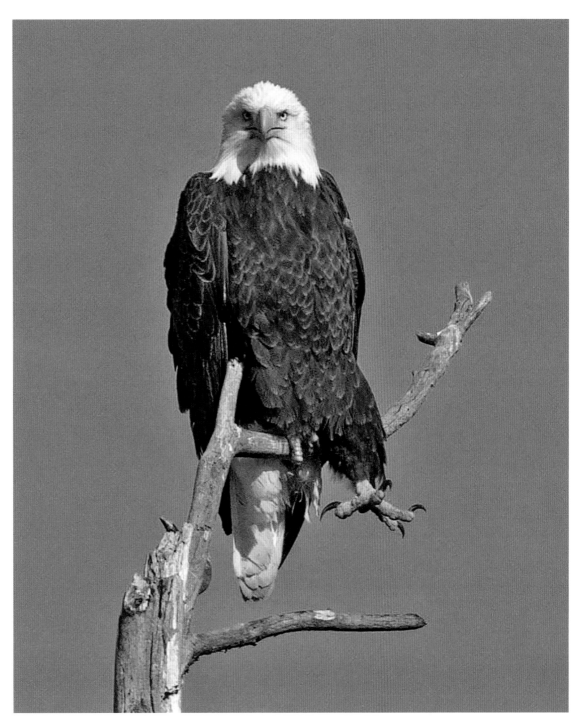

Steroid use was strictly banned, but Terence scored on the black market.

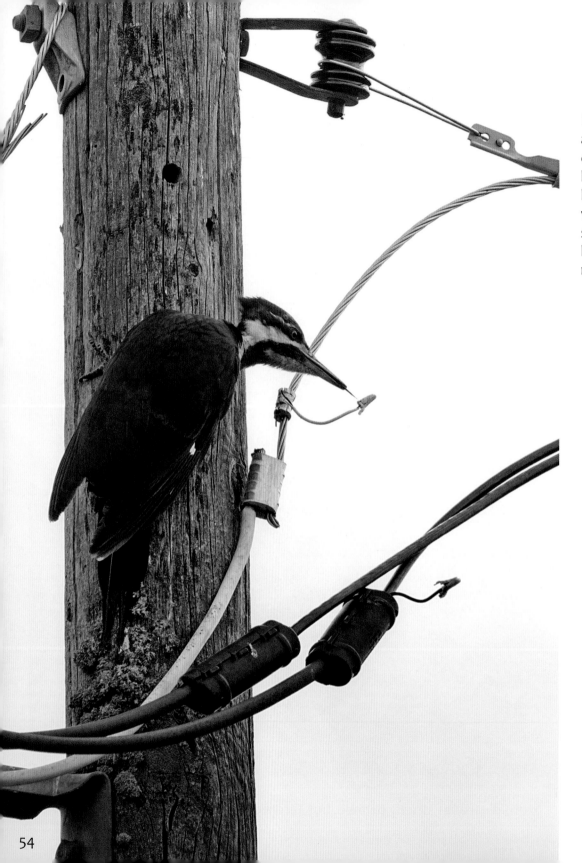

Nina went ahead with the dare but should have learned her lesson last winter when she touched her tongue to a metal flagpole.

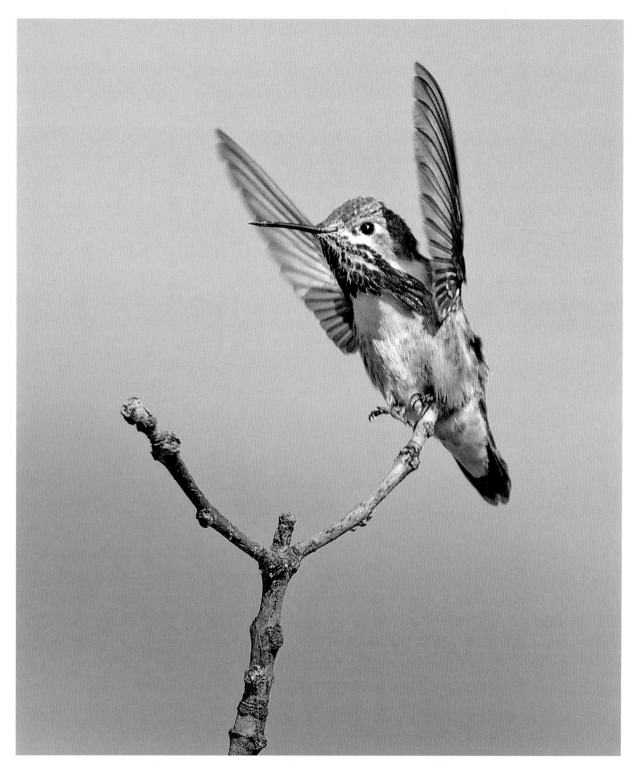

Gary was determined to break the cheerleading squad's gender barrier.

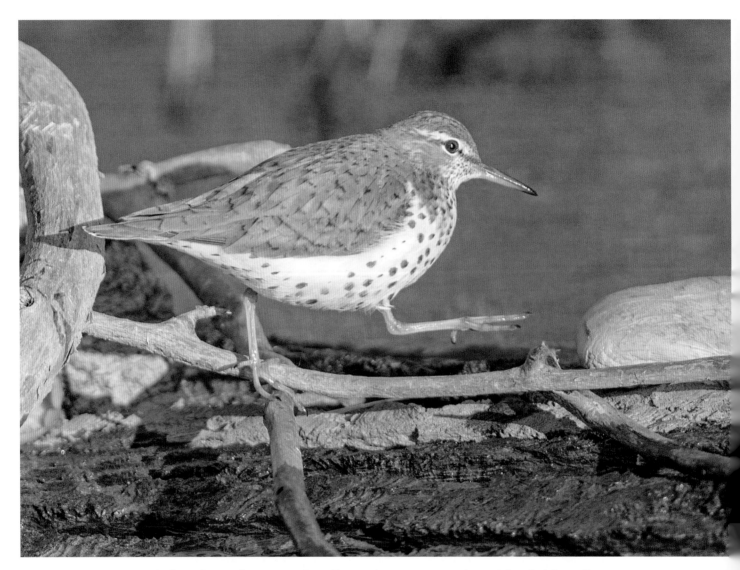

At her doctor's suggestion, Penny began every day with a brisk walk.

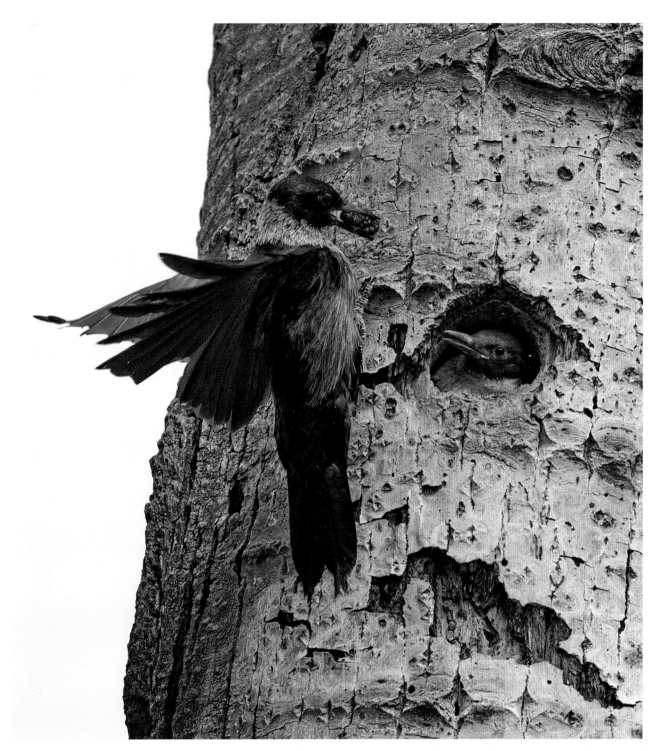

"Berries?! What happened to the juicy caterpillars with their zesty flavor and lovely internal organs?"

Dale blew that pop stand and never looked back. Well, just a peek.

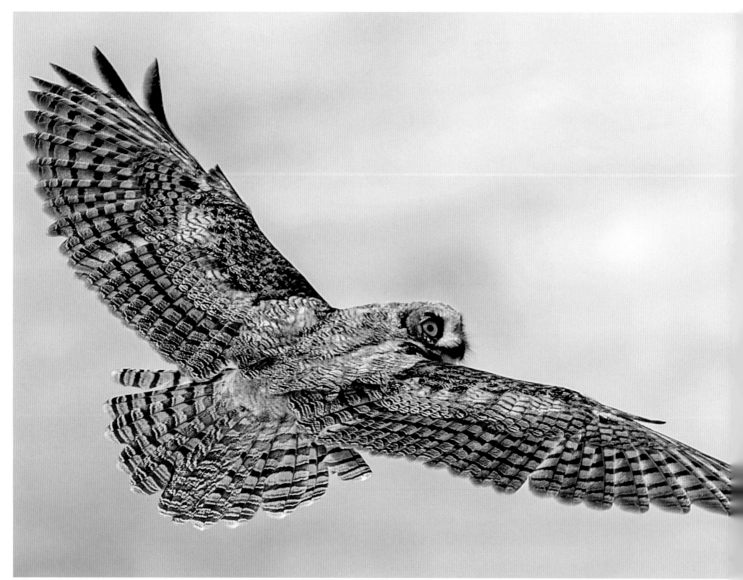

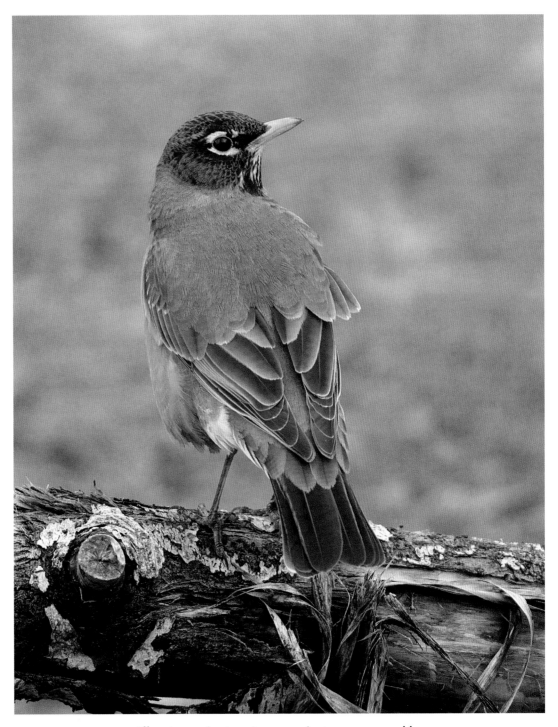

Albert was just not a morning person, and by
the time he got up all the worms were gone.

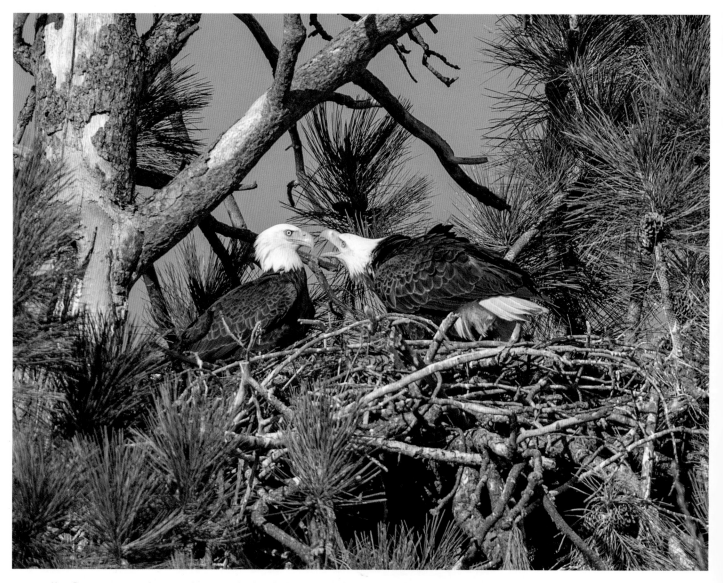

"A fine time to bring this up. 'I don't know if I'm ready for parenthood. It's such a responsibility. I just don't want to be tied down.' Do you see those eggs over there?"

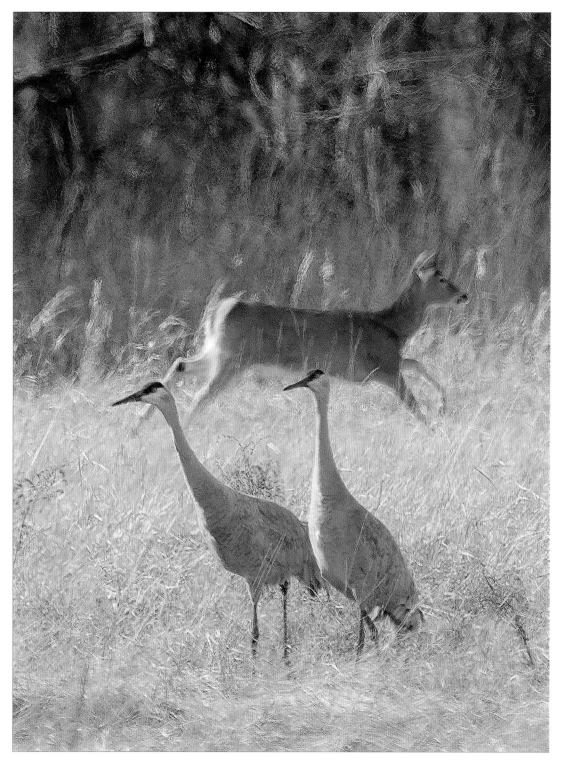

Hiking trails at the bird refuge were crowded on weekends
with outdoor recreationists from all walks of life.

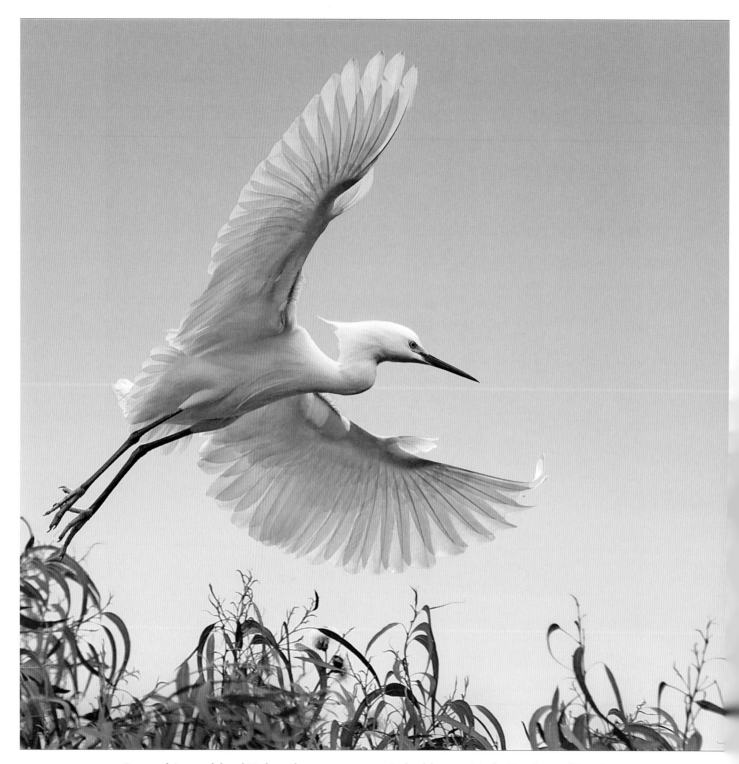

Something rubbed Helen the wrong way in lackluster Little Rock, and instinct said to flee to the bright lights of Hollywood for ultimate film stardom.

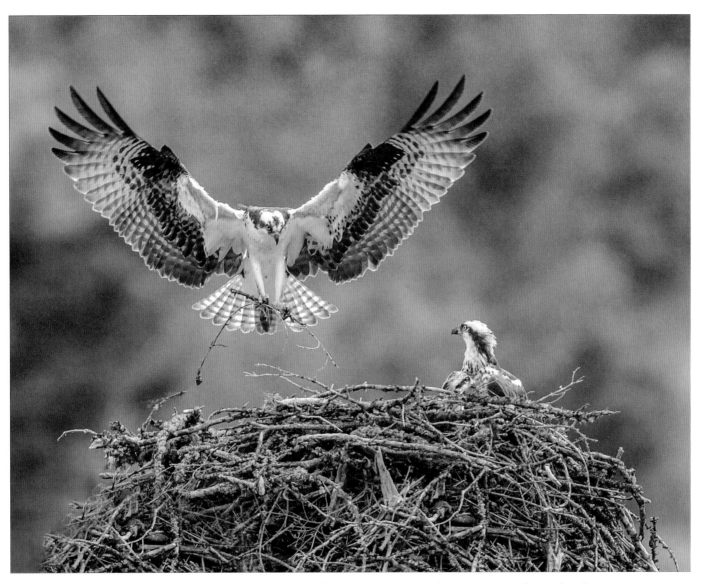

"Oh, just what we needed. Another stick. Your father has saved the day."

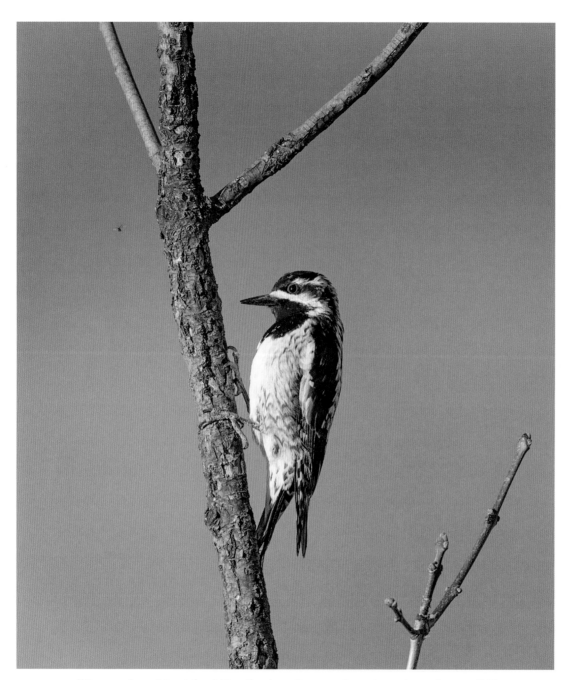

"Some days I just feel like I'm beating my head against the wall."

By New Year's Day, Kyle was sick of holiday leftovers.

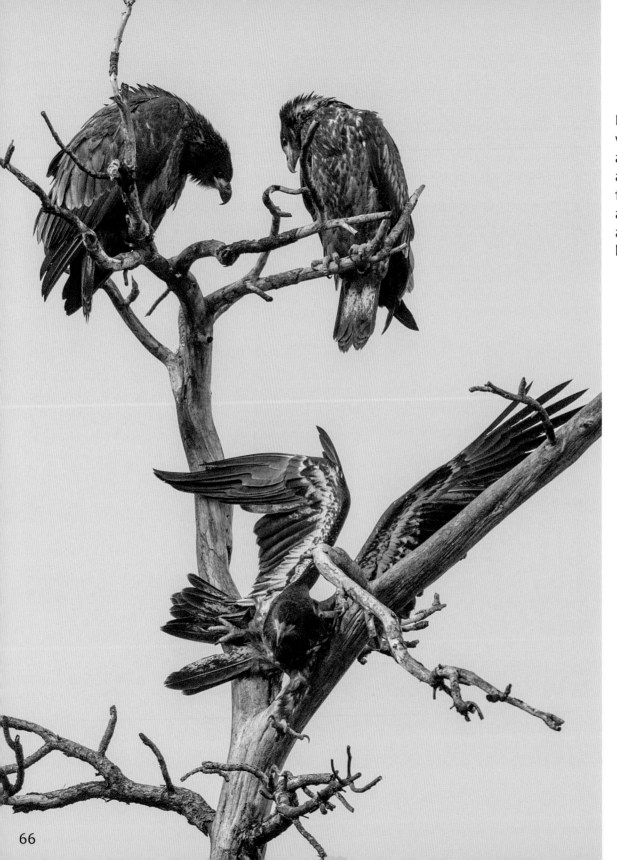

Her sisters watched in amusement as Monica failed yet another attempt at landing.

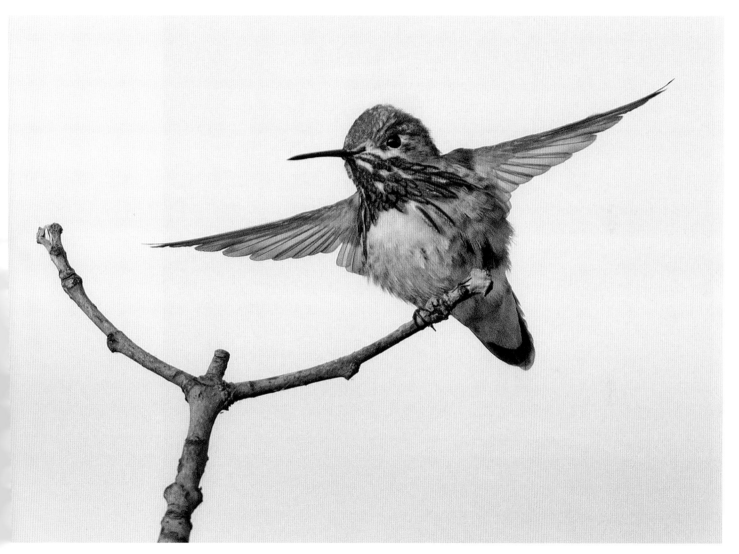

Marty was cursed with a face that made it impossible to blend into the background in this one-horse town.

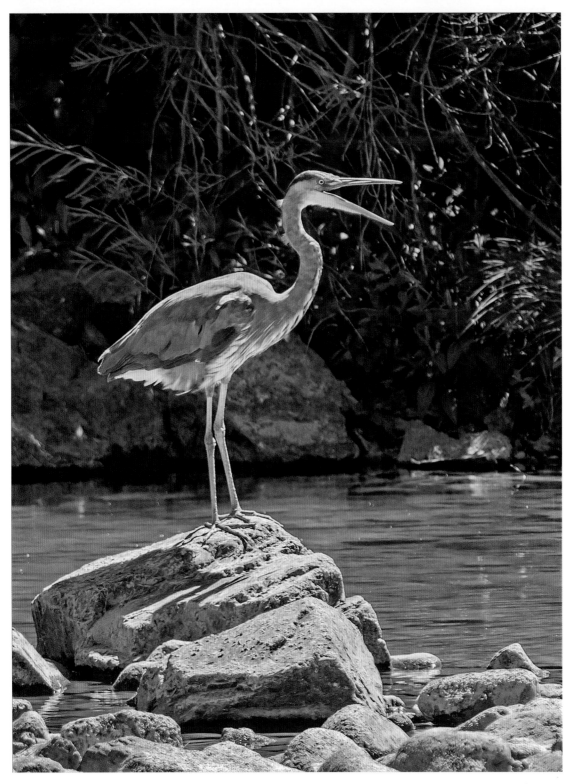

Opera was in the blood, but unfortunately Betty was completely tone deaf.

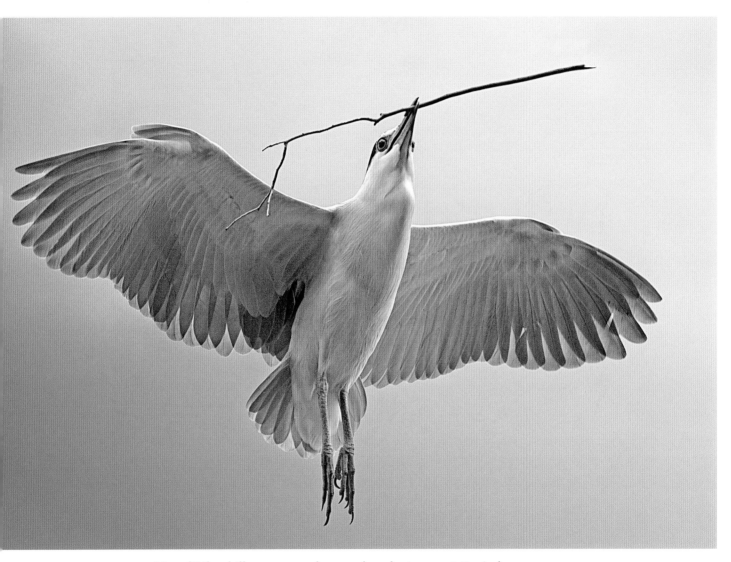

Very little skill, poor grades, and no baton, yet Susie became
leader of the marching band, based on looks alone.

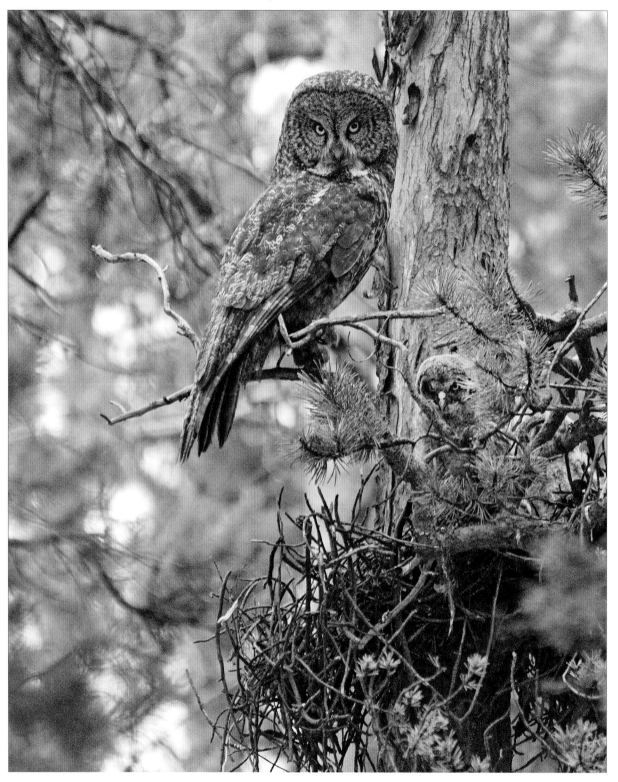

Junior was a chip off the old block, frown and all.

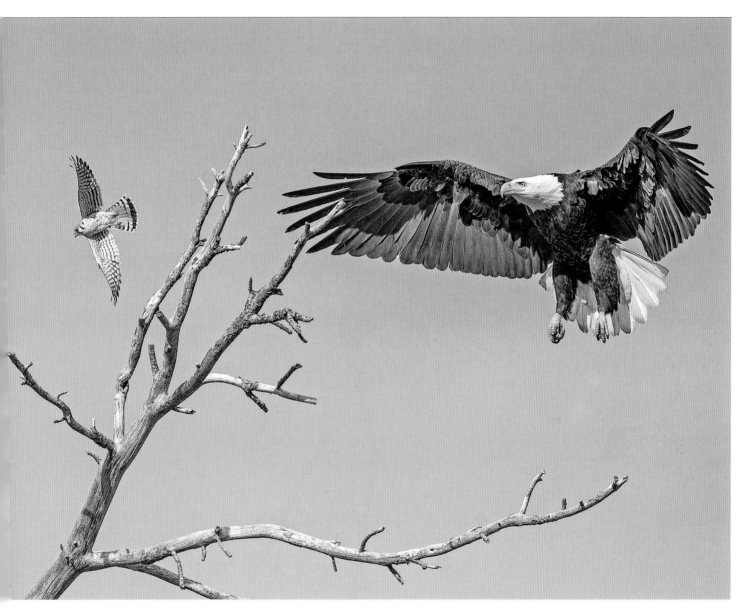

The tables had turned, and Aaron thought it safe to beat a hasty retreat and not to mention this close encounter to the wife and kids over dinner.

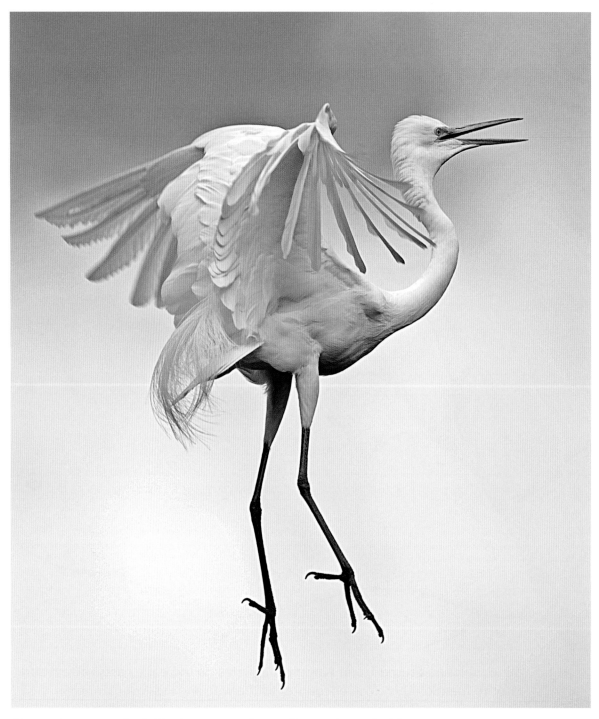

Steve always reminds the lesser species at the rookery that he
is a Great Egret, not just a Good Egret or Satisfactory Egret.

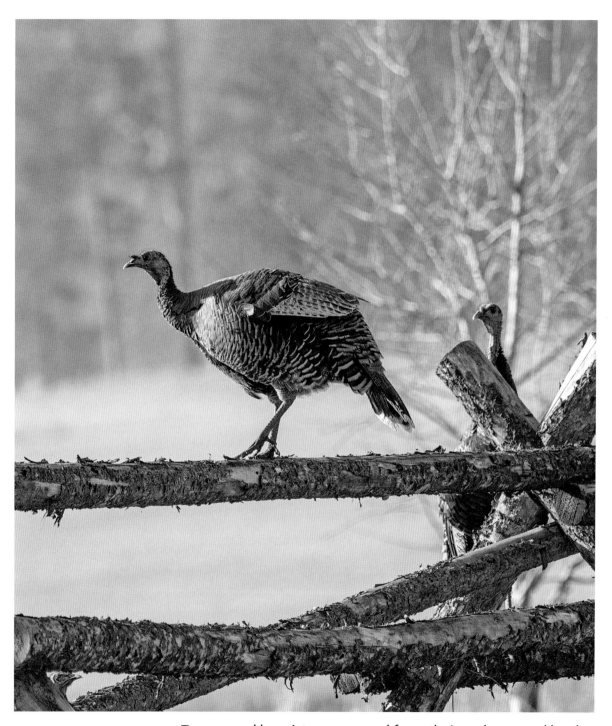

Tammy and her sisters emerged from their underground bunker
the last day of November, safe for at least another year.

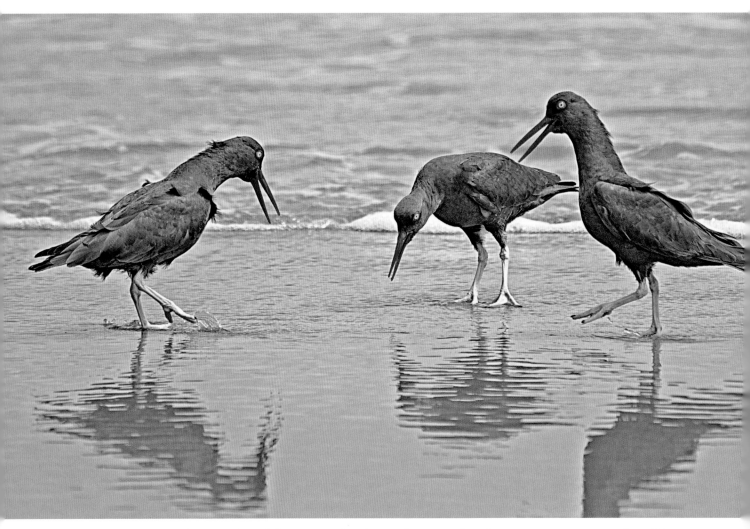

All hell was about to break loose on the dance floor as the dapper newcomer waltzed in.

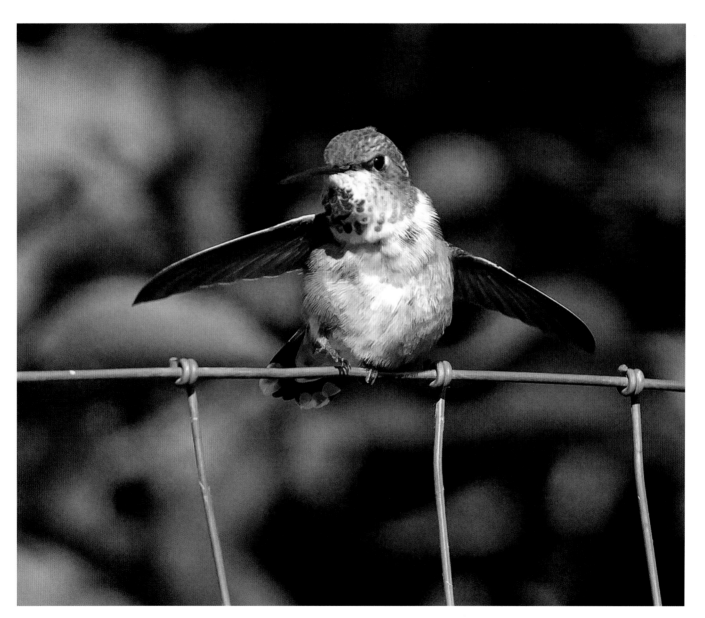

"That hawk missed me by this much. Never had a chance.
You should have seen me." Riley was prone to bragging.

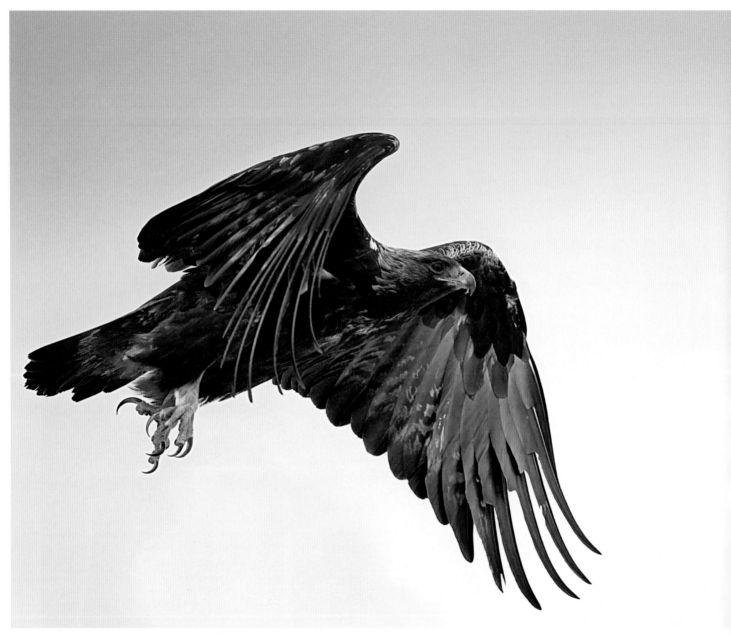

His Latin name translates as "Eagle. Golden Eagle," which always reminded him of "Bond. James Bond."

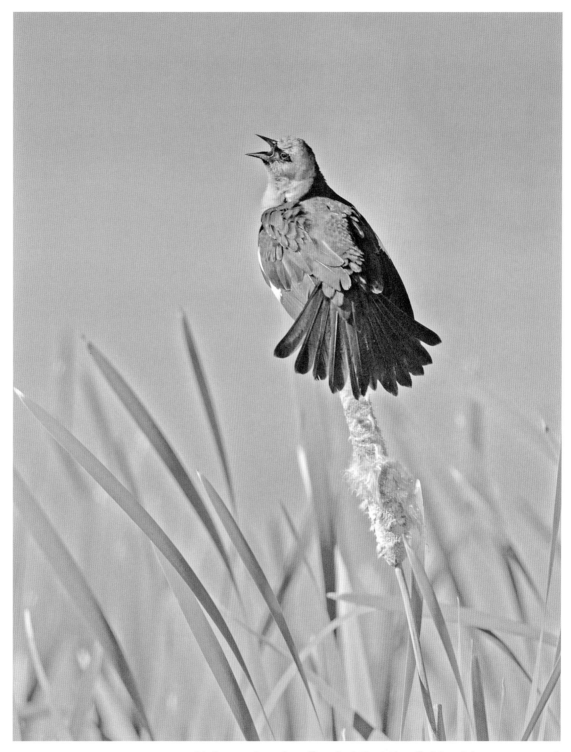

Hal was deeply offended that the field guides compared his musical efforts to "the wail of a chain saw."

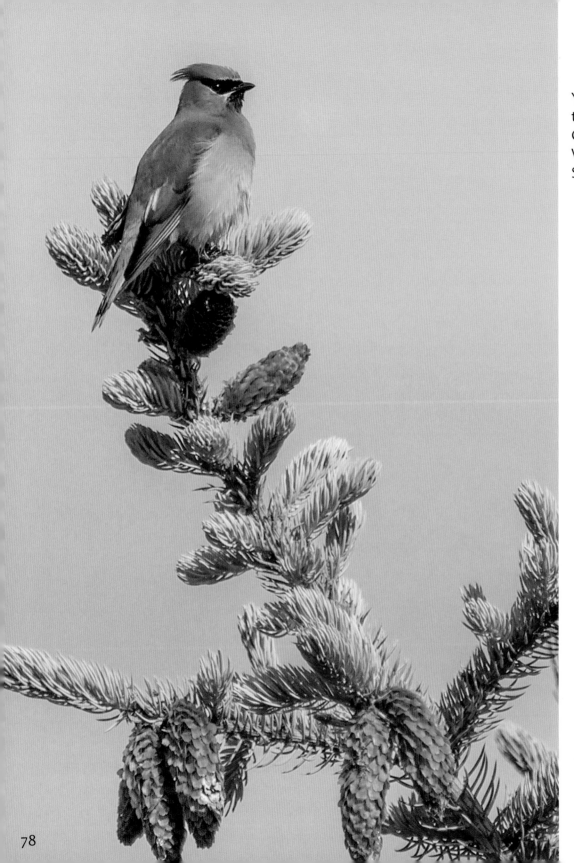

Your gift on the first day of Christmas: A Waxwing in a Spruce Tree.

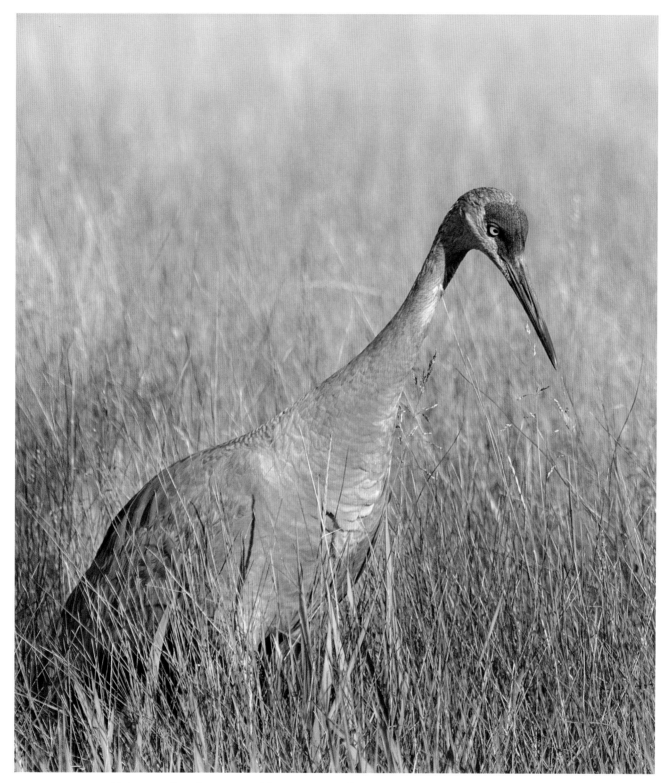

"I know they're around here somewhere. Retrace your steps. When was the last time you remember having your car keys? Think, think."

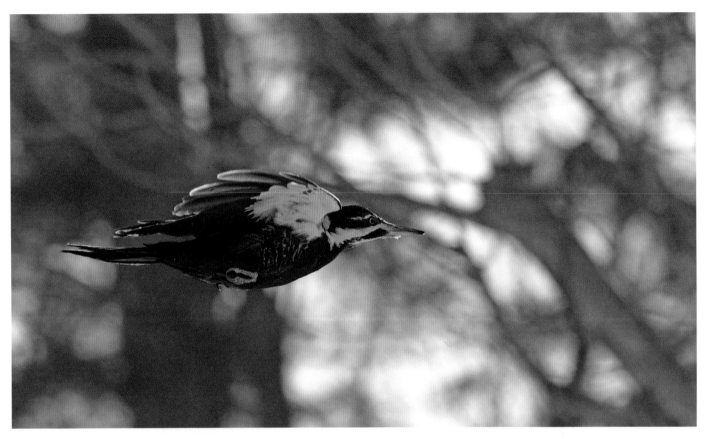

"Wow, I am outta here! I have the wrong colored bandana for this neighborhood!"

Flaps down? Check. Reduce speed? Check. Landing gear down? Check.

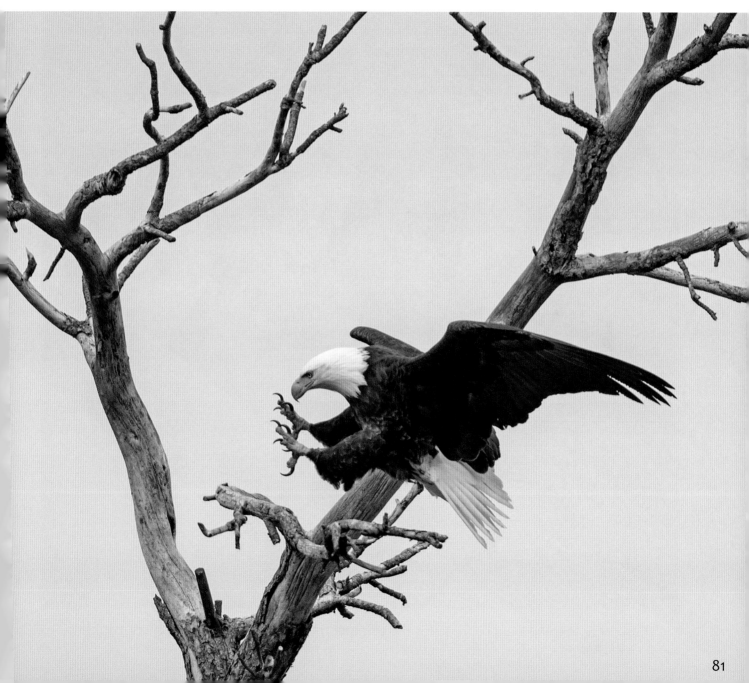

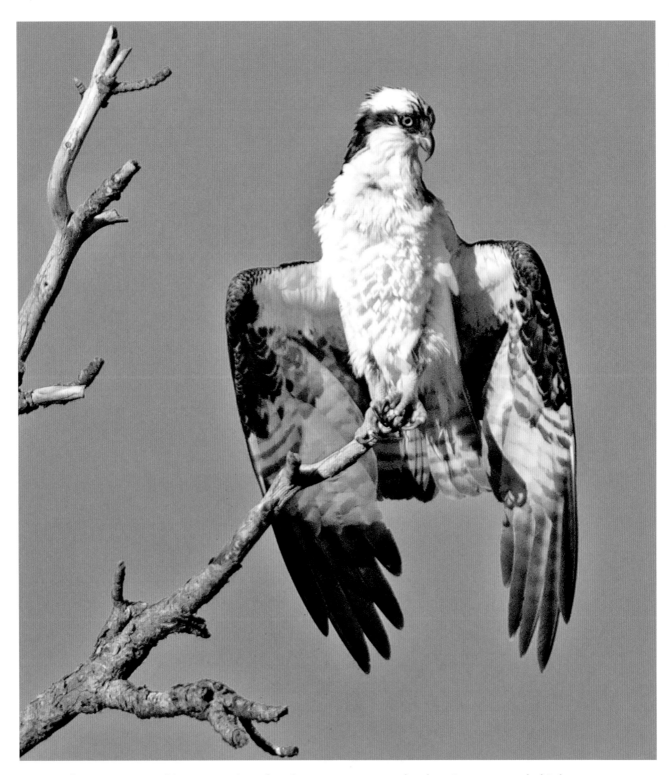

Cashmere seemed inappropriate for the summer months, but it was a real chick magnet.

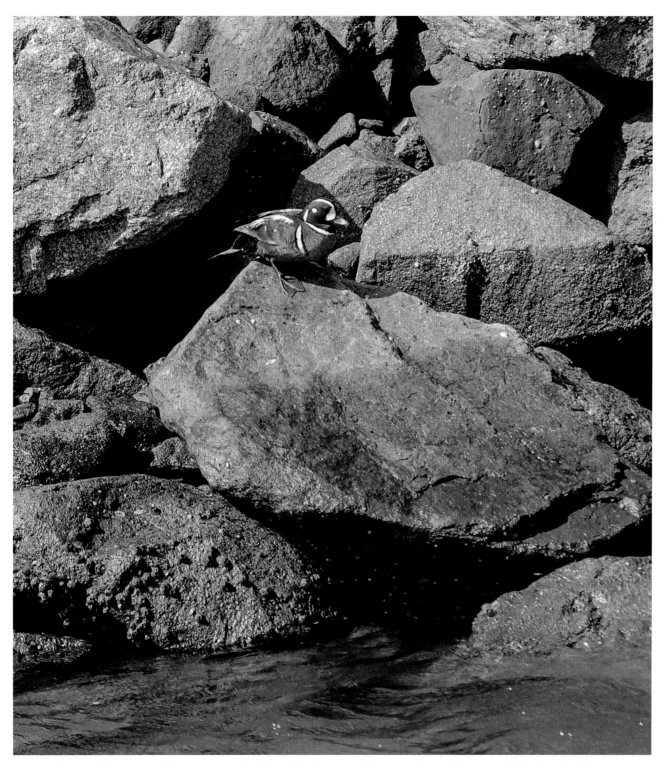

Dave knew if he posed long enough, Mrs. Right would come along for a real Harlequin Romance.

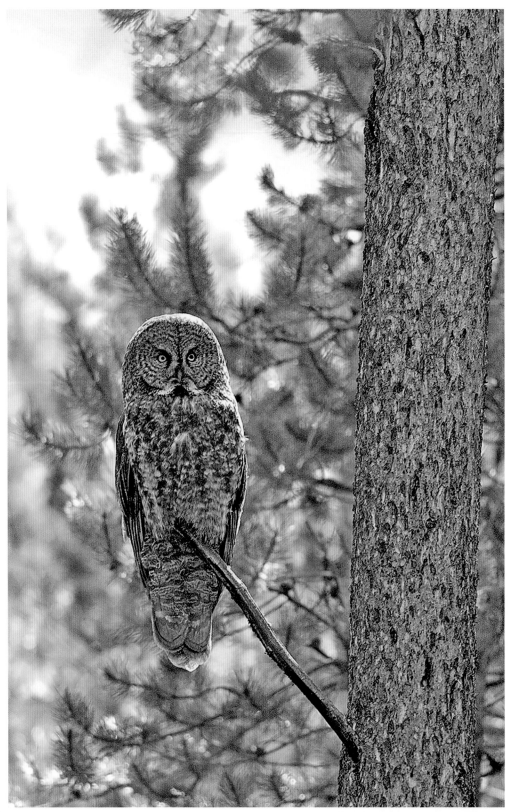

Sylvia always had this faraway look, and no one ever knew if she was paying any attention to what they were saying.

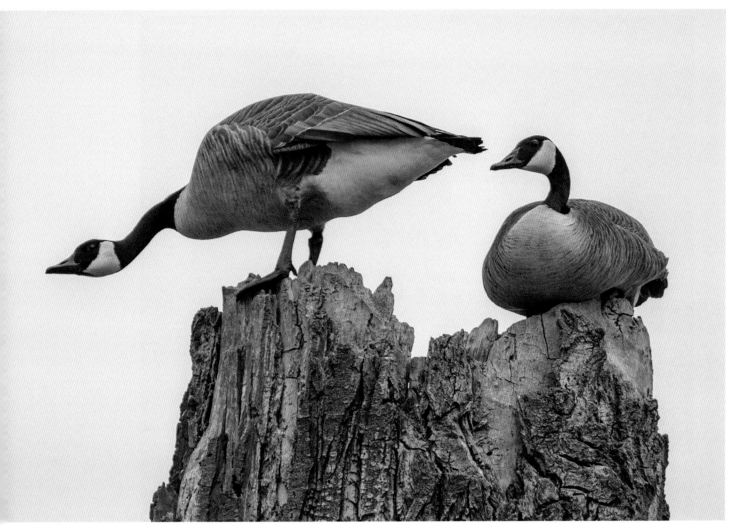

"Why does everyone bring nationality into it? We've never even been to Canada."

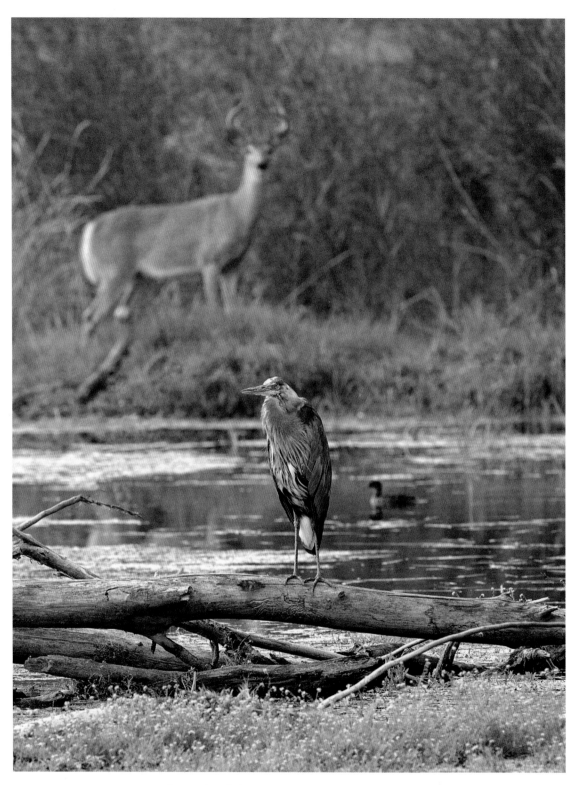

An integrated pond celebrating a long history of racial harmony.

Donna always had the upper hand, even though she was just two days older than her sister.

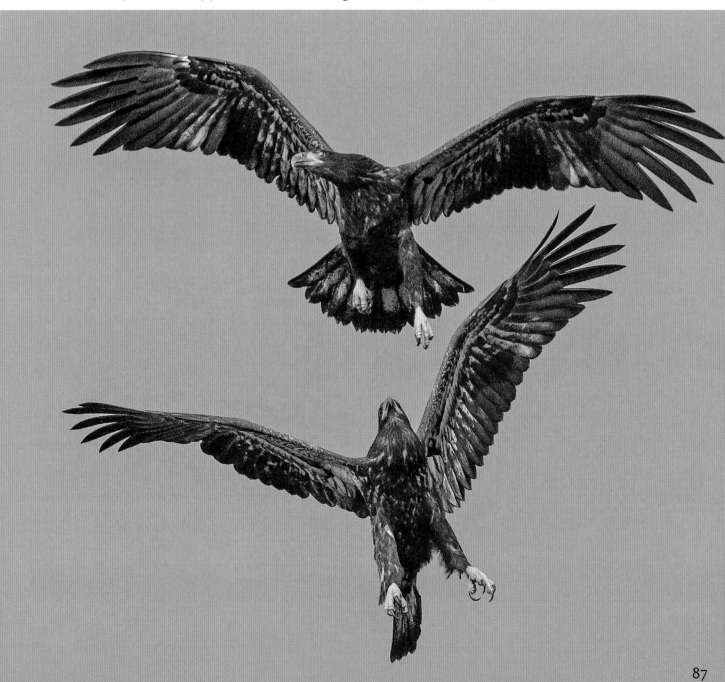

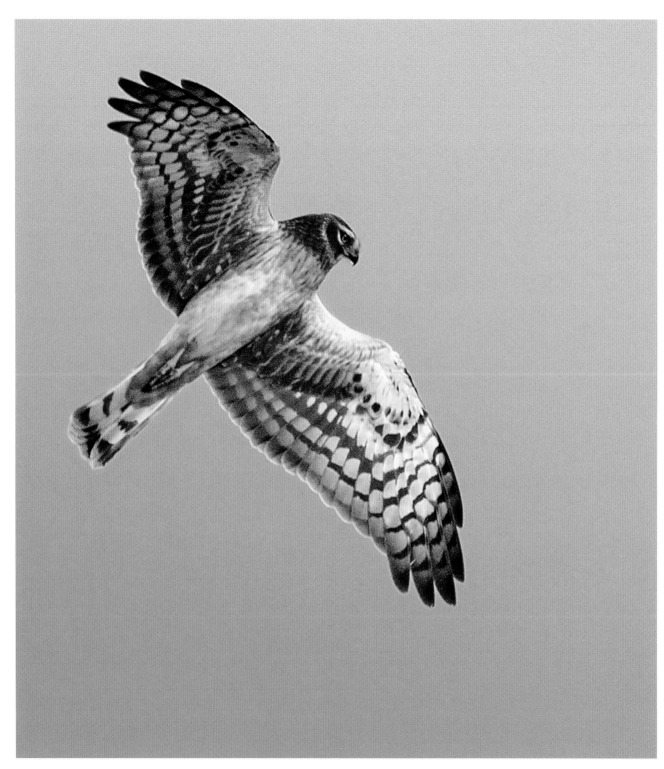

Soon appearing as a tattoo on someone you know.

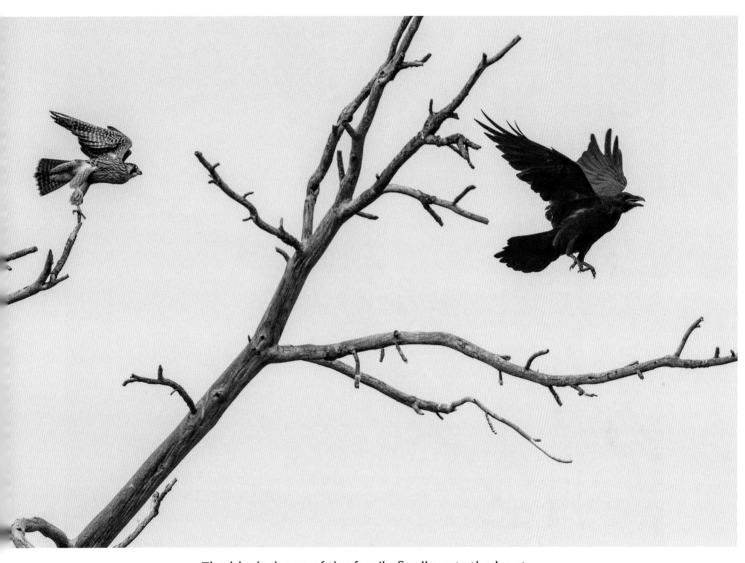

The black sheep of the family finally gets the boot.

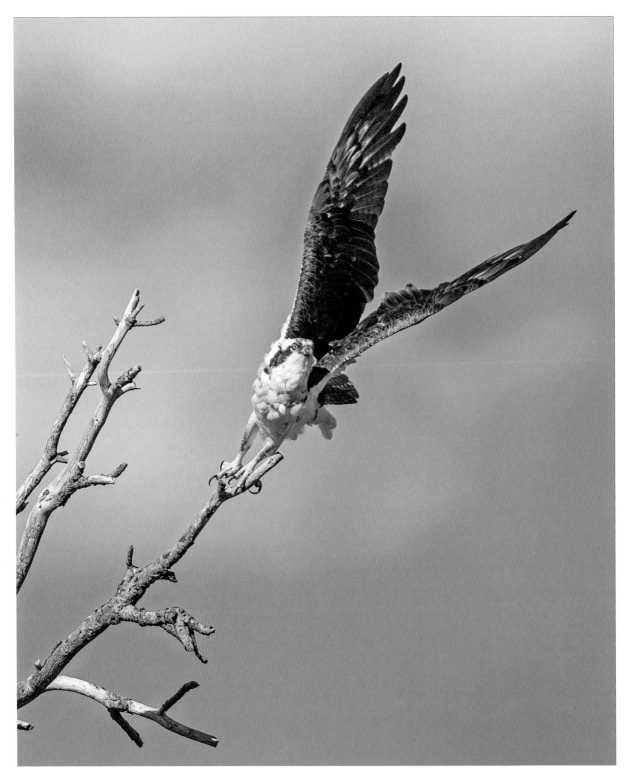

To be a masthead or hood ornament? Ian couldn't decide.

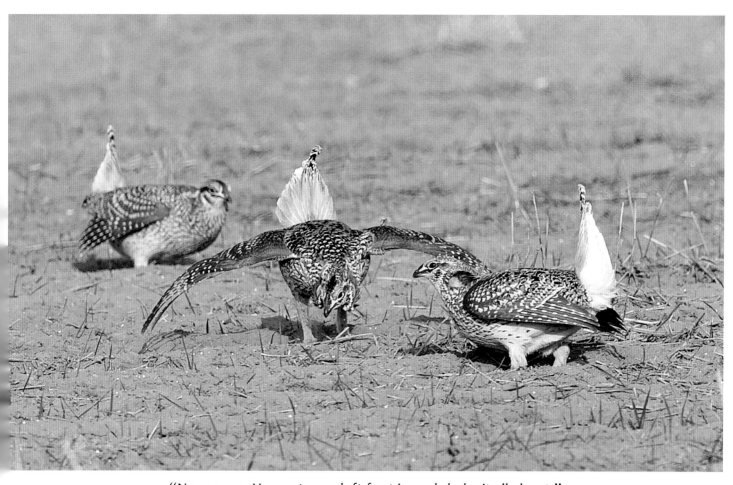

"No, no, no. You put your left foot in and shake it all about."

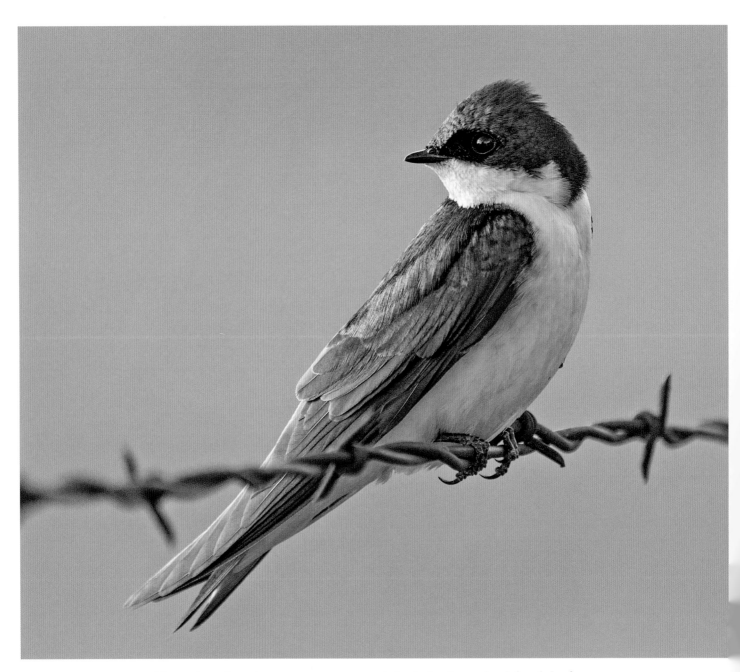

The prison break was a success, and Andy had one look back before his escape was complete. "Free as a bird," he thought.

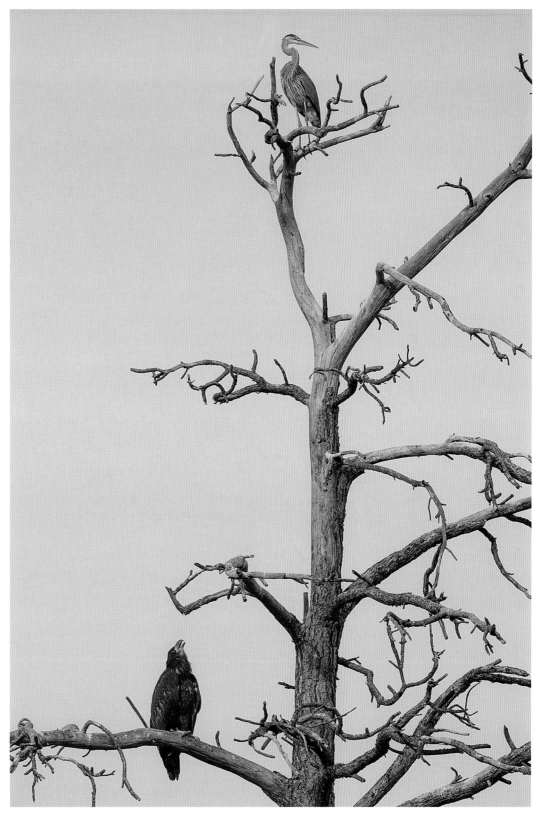

"HA! The cheap seats. Nosebleed section. Upper deck. Probably ordered your tickets online...."

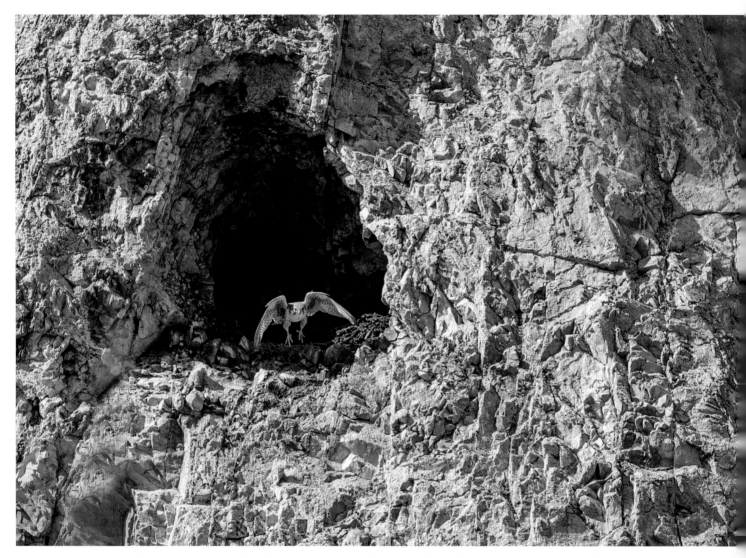

"Crimes to be solved in Gotham City!" Back after this short commercial break.

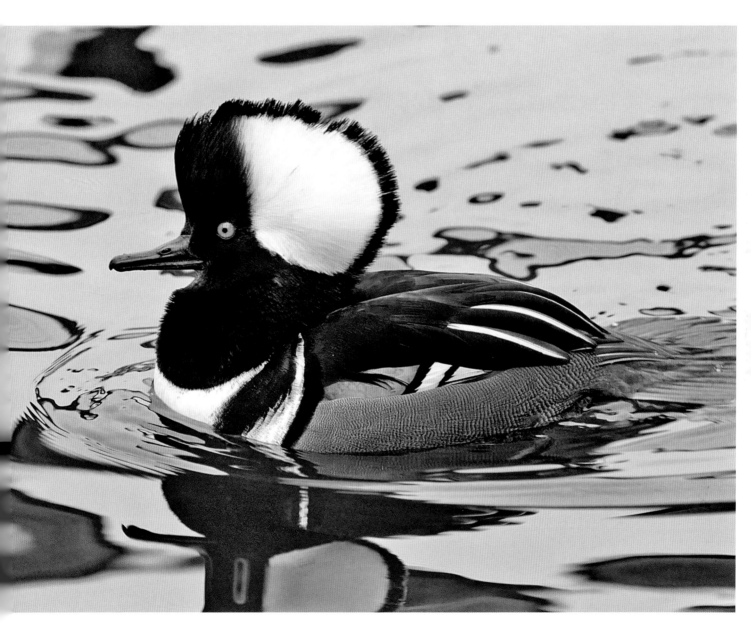
One duck sparked a hair revolution in the punk and alternative scene.

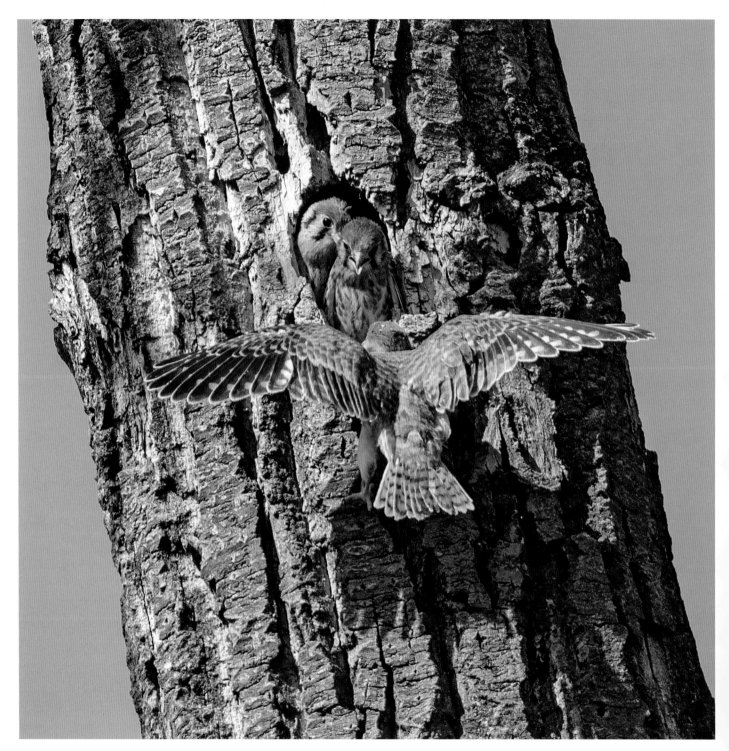

"Hurry up! Our favorite show is about to start, *The Secret Lives of Cavity Nesters*."

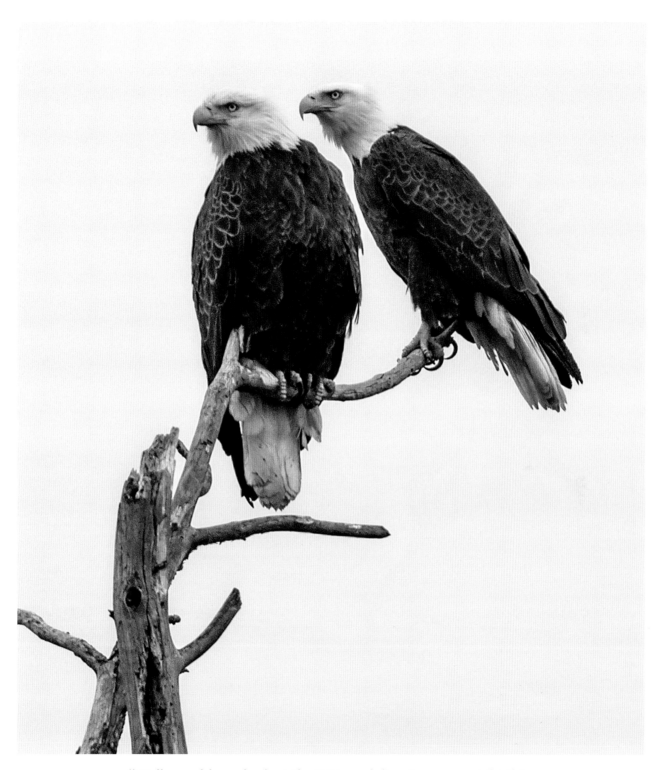

"Well, would you look at that? Pizza deliveries every night this week. And she puts on such airs at the Farmers' Market."

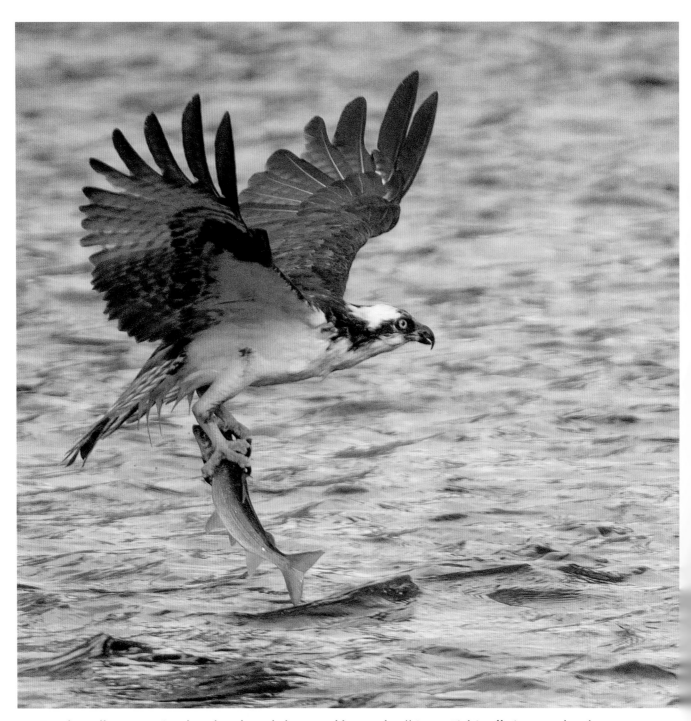

Frank really meant it when he closed shop and hung the "Gone Fishing" sign on the door.

First Stanley tried a beard, then a goatee, but the mustache was the secret to his status as a ladies' man.

The castaway didn't really want to be rescued. As a matter of fact, he never wanted to ever see another alarm clock and was glad for an excuse to sleep in.

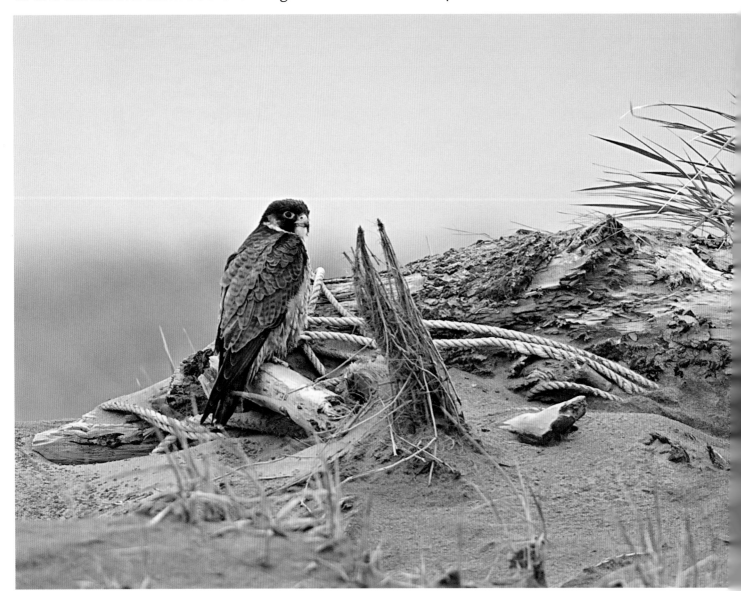

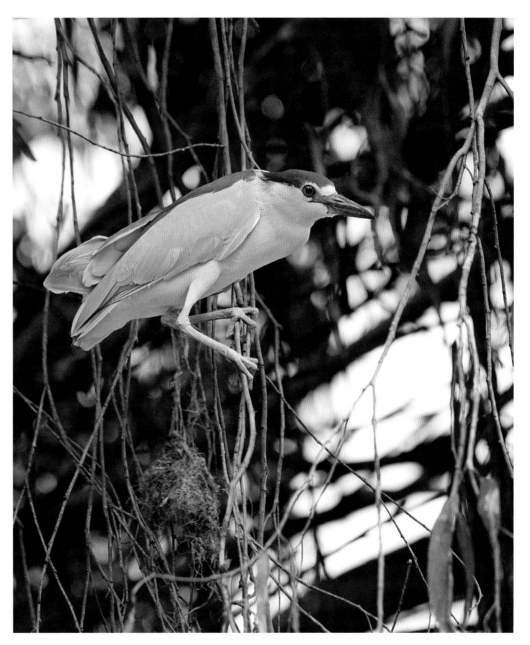

Swinging Singles Scene at the Night (heron) Club, vines and all.

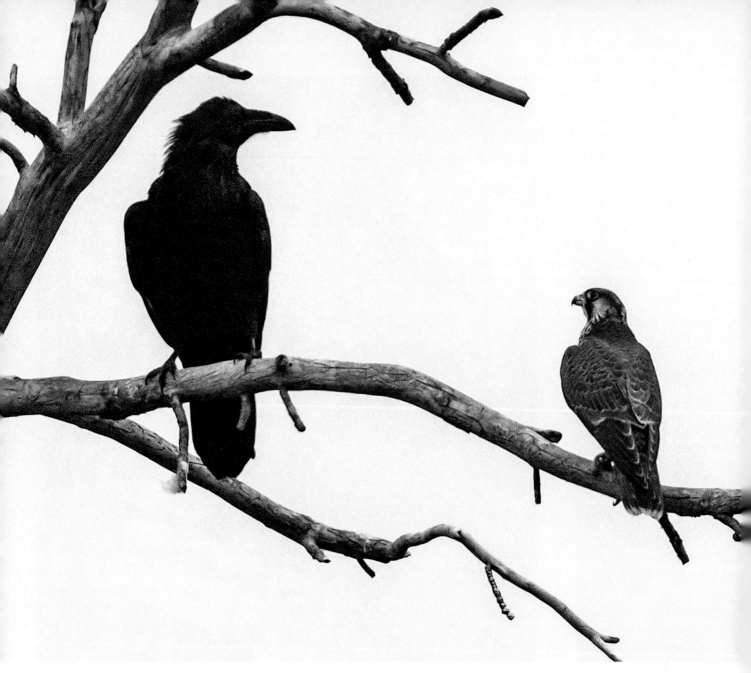

Finding they had nothing in common, they decided to part ways and never again use datehookup.com.

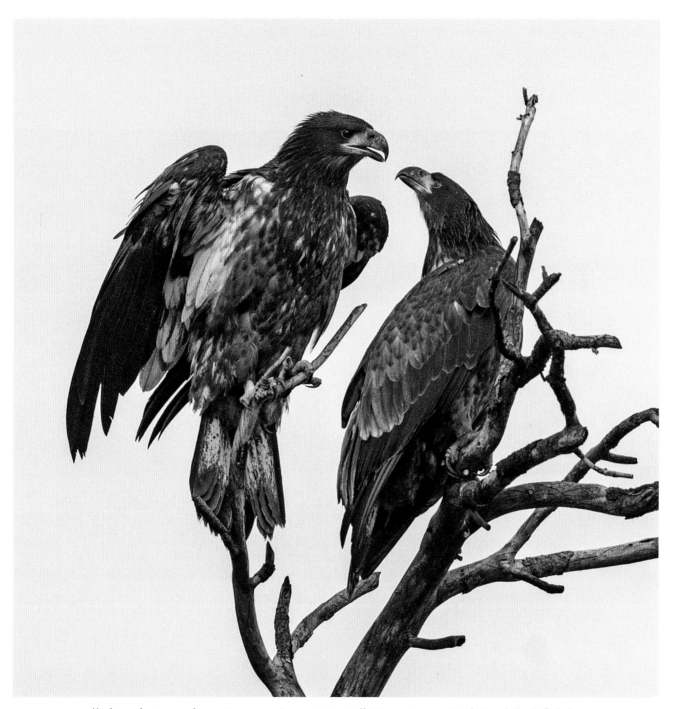

"Okay, but you have to promise not to tell Mom. I saw Dad steal that fish he brought us from an Osprey. He didn't catch it himself, Mr. Pants on Fire!"

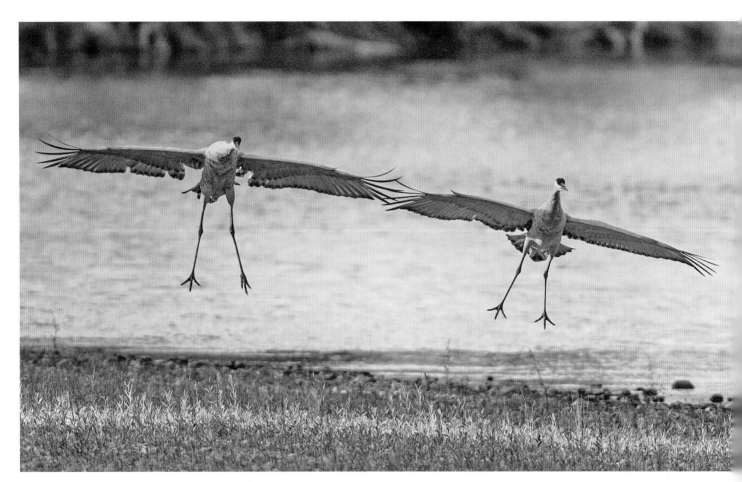

A Symphony in Coordination, or at least a Sonata.

Arriving several weeks earlier than the others, Ben had no trouble finding a parking place.

"Ah . . . sunset strolls on the beach, plenty of caddis fly larvae, and not a worry in the world. This is the life."

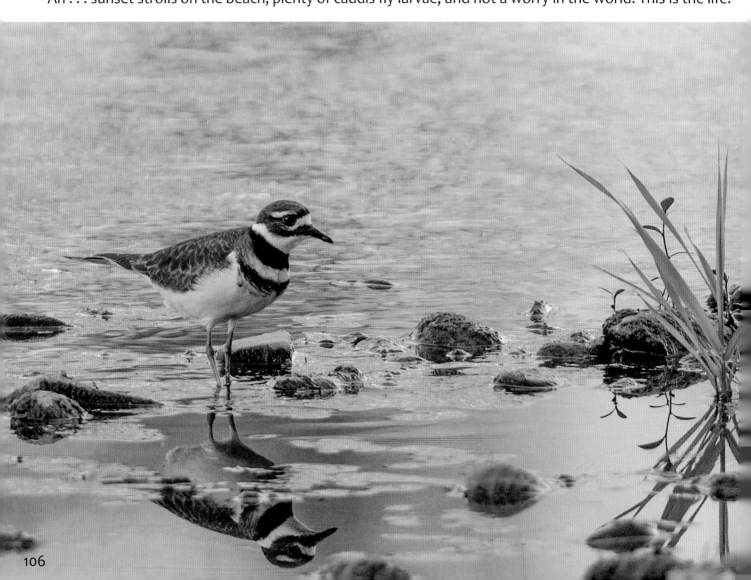

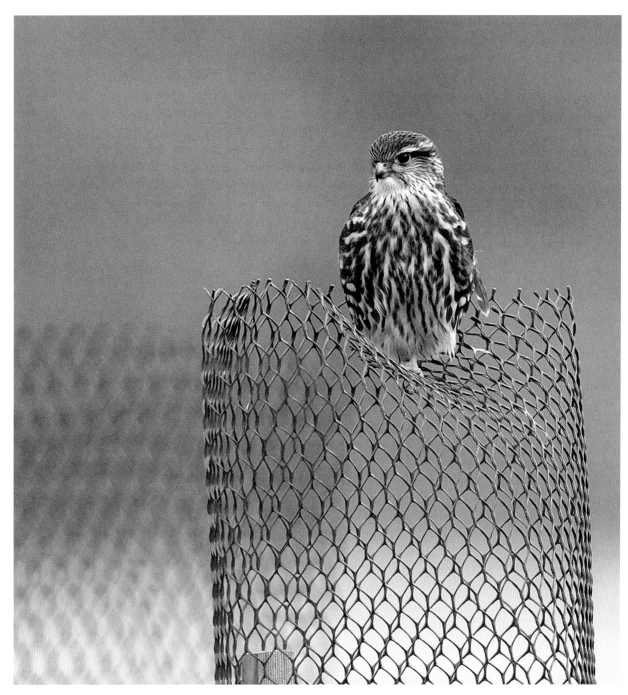

"What happened to the grove of aspen trees? This place has gotten way too commercial," she thought.

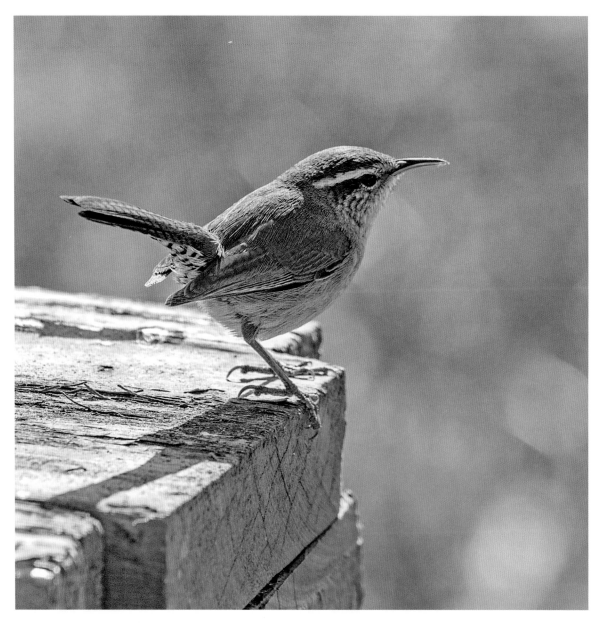

Roy came to an abrupt halt after it was suggested he take a long walk on a short pier.

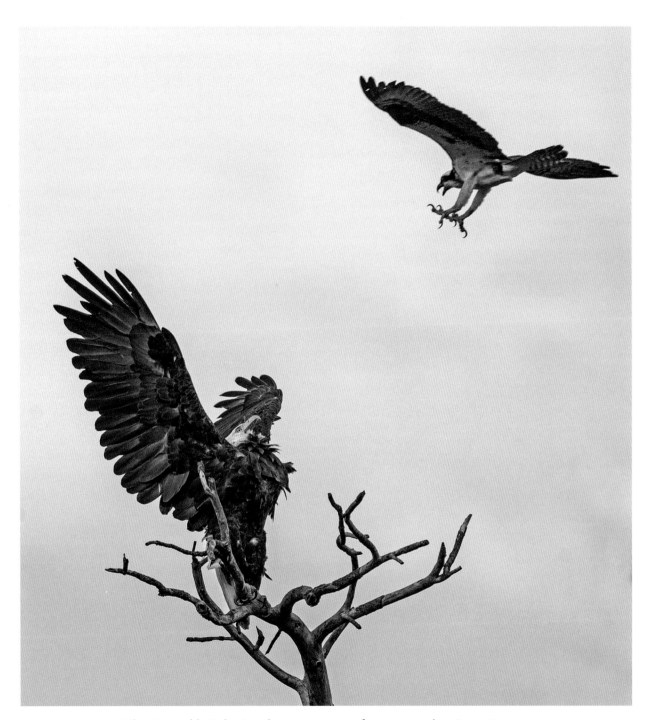

Hilarity and hijinks in a happy game of tag over the river. Or not.

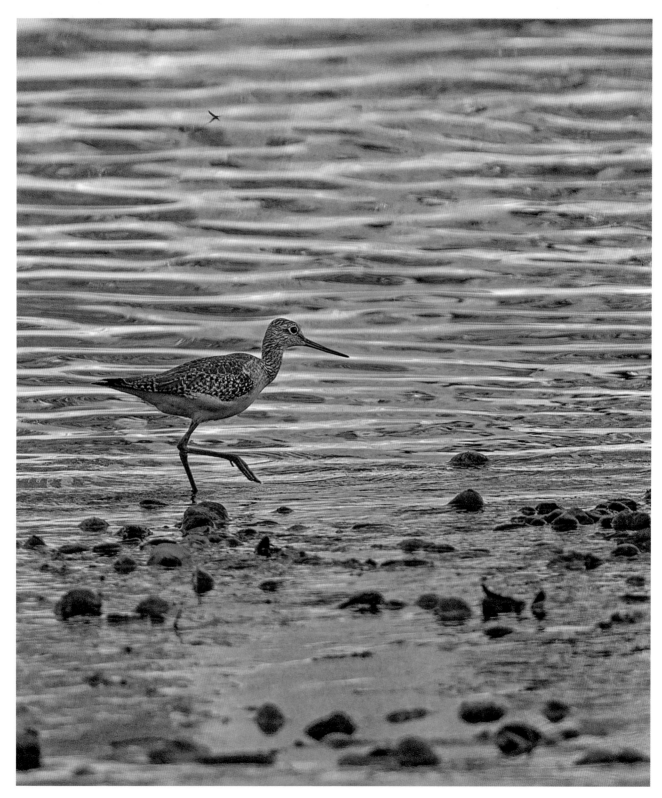

Cecilia practiced for hours before wearing her new spike heels in public.

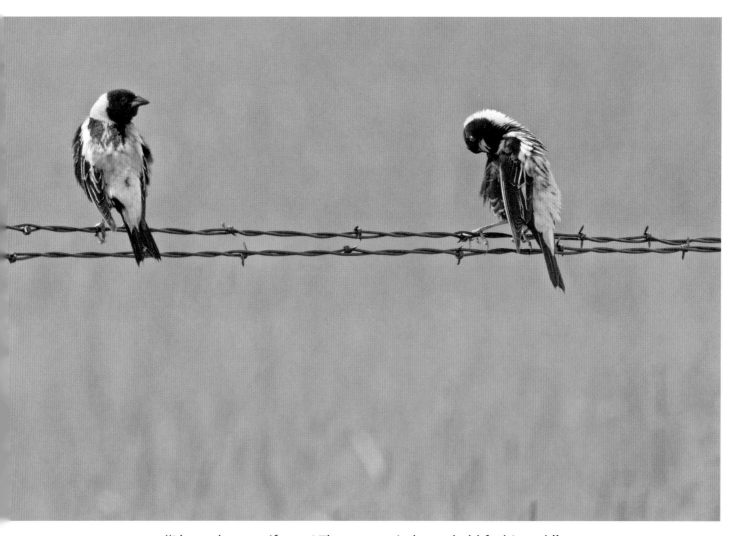

"I hate these uniforms! They are so itchy and old-fashioned."

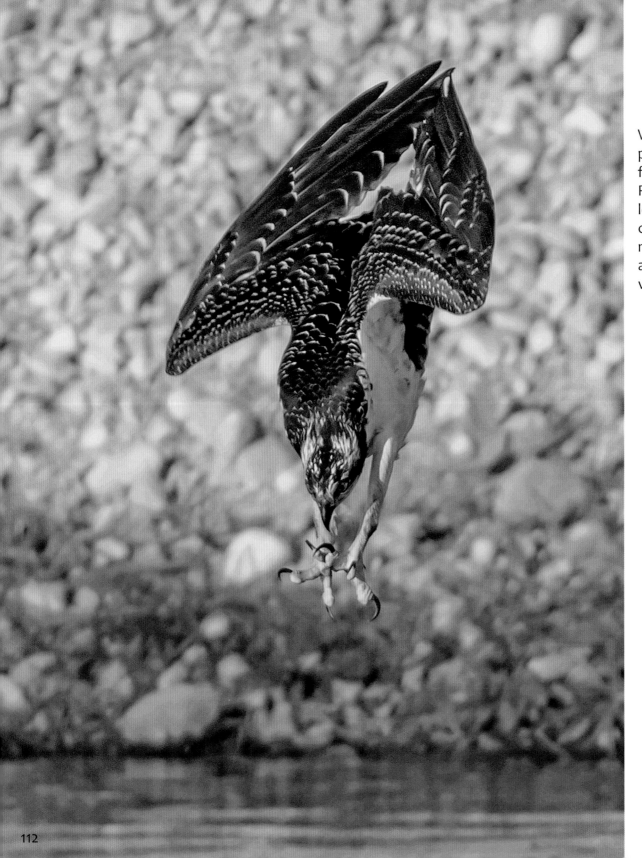

While perfecting fishing skills, Rudy's learning curve was more like a straight vertical line.

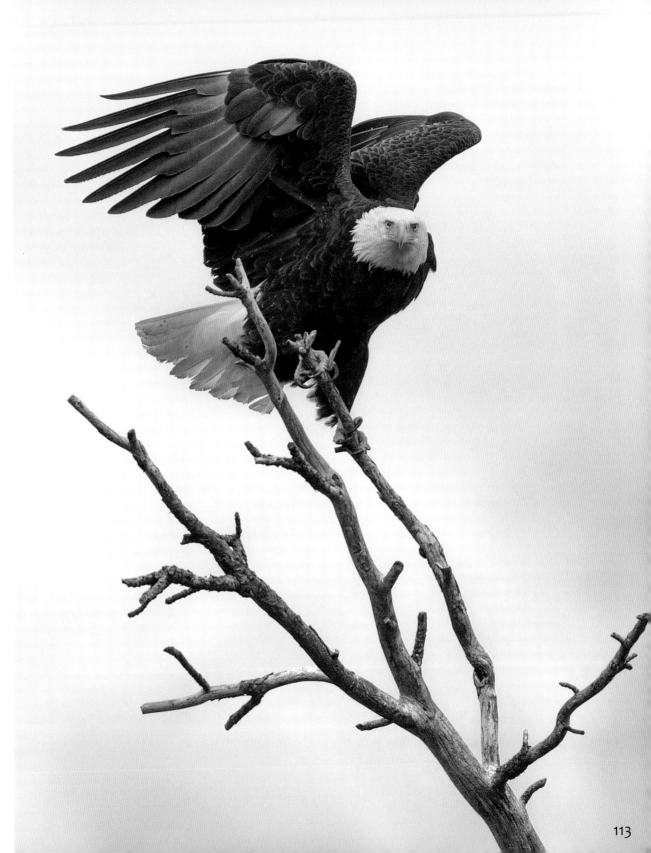

Daphne knew that the paparazzo was always lingering in the shadows, waiting for that one compromising photo for the *National Enquirer*.

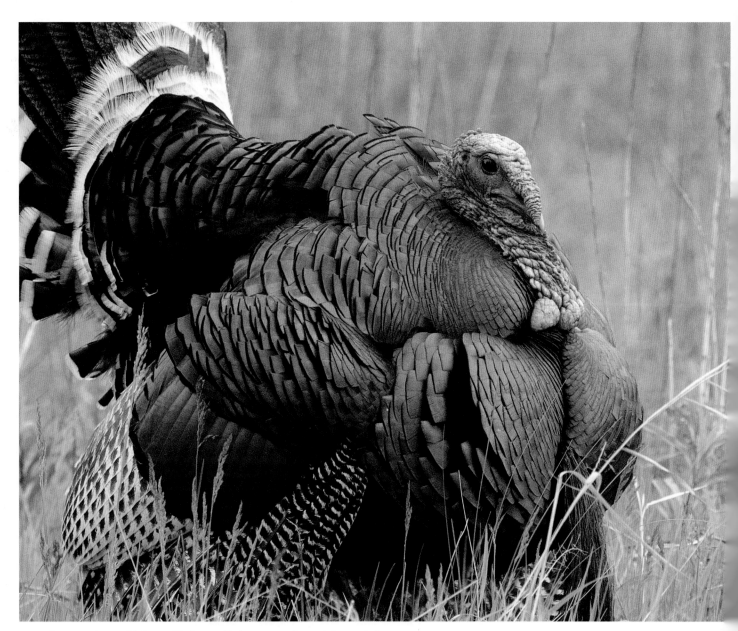

Randy convinced himself that all the months with Weightwaters
were paying off and that the scales must be lying.

Kevin beat a hasty retreat when it came time for heavy lifting and clean-up.

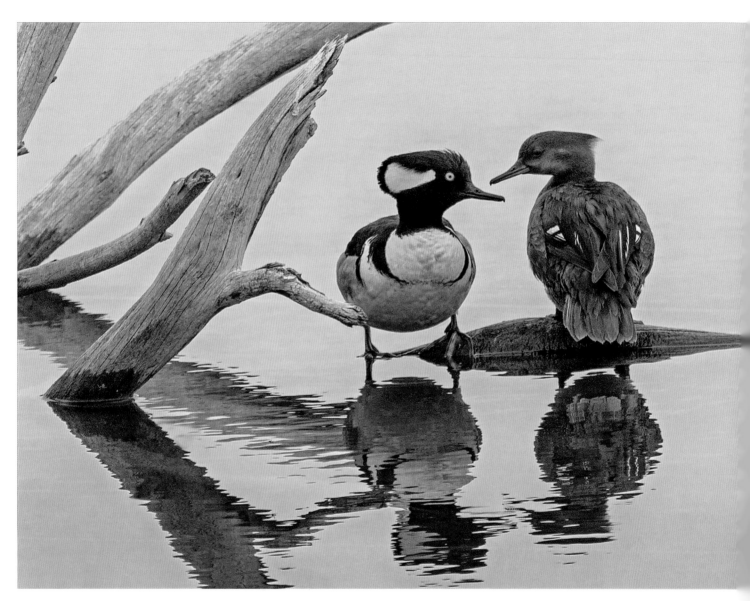

Everyone thought Beth was a wallflower, but she lived for locking horns in intellectual debate with the boys on the beach.

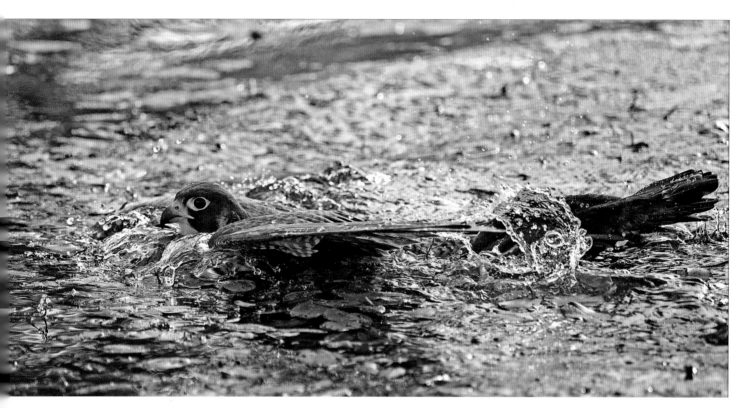

The new fitness trend, "Row with a Duck in Tow," was a cinch for Carla, who knew no boundaries.

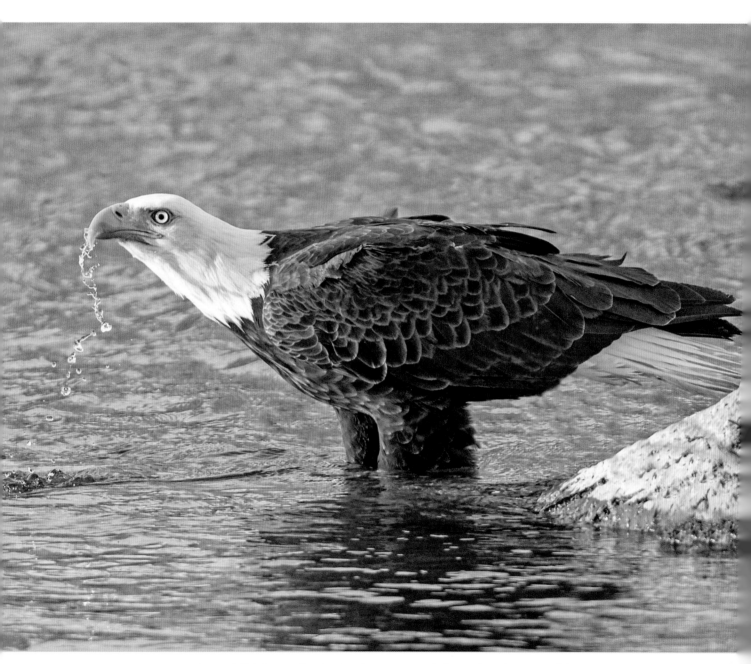

As a child Pete always had to wear a bib at the dinner table.

NOTES TO THE PHOTOGRAPHS

Notes organized by the page on which the photo appears.

iii Pair of Pileated Woodpeckers in the front yard.

iv Sonora the Aplomado Falcon.

2 One summer we had a small colony of Cliff Swallows nesting under the eaves of the garage, a delight to watch.

3 This baby American Robin bailed from the nest early and had to be returned. Parent songbirds don't reject babies touched by humans because they can't smell anything.

4 The Bald Eagle pair behind our house began courtship months before nesting. My favorite photo of the 2015 season is the male landing next to his mate.

5 Three baby Western Screech-Owls were roosting, and when I took this photo I didn't even know if their faces were showing. I was shooting into the shadows through the bright sun.

6 Some people are surprised to learn that Wilson's Snipe do exist. You may have been tricked into a "snipe hunt," a pointless venture into the night as a practical joke.

7 Beginning birdwatchers may be encouraged by American Kestrels because they are easy to spot and the sexes can be told apart even at a distance.

8 On the Washington coast, a flock of Dunlins balled up, packing in tightly as a defensive tactic, while a Peregrine Falcon stooped from above.

9 A young Great Blue Heron perched several times above the eagle nest in the Ponderosa Pine and screamed an un-regal squawk when the male eagle reclaimed his favored spot.

10 The South Texas Coast hosts a great number of aquatic species, including these young and adult Black-necked Stilts and a Black-bellied Whistling-Duck that showed up in the mix.

11 Great Gray Owls used this old Northern Goshawk nest for several years until it finally fell apart. Owls don't build their own nests, and the pair moved the following year.

12 The Bald Eagles on the beach by our house have been nearly constant guardians of their territory; this landing shot was taken in March.

13 Great Blue Herons have a regal poise and almost mechanical strut; this one on a fence made me think of a skilled gymnast.

14 This Peregrine had a long bath in a stream of fresh water flowing into the ocean in Washington, then ran back and forth in the shallows, perhaps just for fun.

15 A Great Horned Owl sat tight in a Cottonwood tree hunkered up inconspicuously against the bark, but then suddenly flushed.

16 A young Belted Kingfisher was about to fledge her nest, a tunnel in the dirt bank of a creek, complete with a nesting chamber, excavated by the parents scraping with their feet.

17 The male Bald Eagle flew into the nest with an evening load of grasses from across the river. The young were several weeks old. Materials were added all nesting season.

18 The rattling call of a male Belted Kingfisher carries a long distance. Both sexes have the slate-gray band across the chest, but only the female sports a rust-colored belt and sides.

19 Two male Ring-necked Pheasants duked it out in our yard in April, one establishing a breeding territory. The leaping, kicking, and biting was a big show.

20 A Western Meadowlark was singing his heart out. The State Bird of Montana, meadowlarks are here less than half the year, migrating south for the winter.

21 A Washington coast Snowy Owl had a few sips of rainwater from a little puddle in a feature I called *driftwood*, and was corrected. The proper term is *root wad*.

22 A Black-chinned Hummingbird shows up at our house every spring and picks this same perch in the yard; here he was grooming a toe in the morning sun.

23 The supermoon of 2014 was rising behind the Bald Eagle tree with the adult male on the moon's edge, fledgling below his father and nest below him to the right.

24 A female Pileated Woodpecker took a break from nest cavity duties and caught some sun by the river across from the eagle nest.

25 Usually seen flying high in the sky, a Common Nighthawk, with his camouflage plumage, was roosting on our fence rail, watching through little slits in his eyes until I got this close.

26 An Osprey dove for fish at Flathead Lake, plunging several feet into the water. They just feed on fish at the surface and on those in the shallows.

27 Great Horned Owls nested on the ground in the stone remnants of the foundation of a building, a strange place for a brood of four young. This one flew out then back as I left.

28 Chesty, a Harris's Hawk that lived at Raptors of the Rockies, flew around the property nearly every day for twelve years, sun or rain or snow.

29 While photographing the eagles at the river I noticed a near-full moon rising in the distance and moved the tripod slightly downstream to capture the scene.

30 A very striking duck, a male Hooded Merganser sailed down a slough at high speed.

31 A female kestrel was escorting a Red-tailed Hawk from her nesting territory near Salmon, Idaho. What I thought was a stick turned out to be a snake, probably a Western Racer.

32 Sandhill Cranes were making an autumn retreat south in migration. Their bugling or rattling calls may be heard more than two miles away!

33 Northern Shrikes, whose Latin name translates to "butcher watchman," are accomplished predators hunting small birds and mammals.

34 The Northern Saw-whet Owl that Raptors of the Rockies keeps for educational programs posed in a cavity previously used by owls. The tree blew down, and the one remaining nestling was later released at that same site.

35 A week after the Bald Eagles fledged, all three were standing on the beach one evening. These two played with a tennis ball for a while then resumed their begging.

36 Our Peregrine Falcon Sibley ran down and caught this hen Mallard in level flight, duck tail feathers clenched in her right foot.

37 One evening a half dozen Common Nighthawks descended into our front yard, perhaps catching flying grasshoppers. I got twice as many photos of sky as of birds.

38 A Short-eared Owl was flushed from the sagebrush and spied our two dogs, the culprits. Bitterroot Mountains in the background.

39 Rough-legged Hawks migrate from the arctic and subarctic to southern Canada and northern United States, wintering in open country that reminds them of home.

40 A massive flock of Dunlins on the West Coast raced through the surf. With lightning-fast reflexes they avoid mid-air collisions.

41 Three Great Blue Herons were displaced in midwinter by a Bald Eagle flying in to claim the perch.

42 The three 2015 Bald Eagle fledglings perched together in the favorite snag by the nest. Equal in size, they turned out to all be females.

43 Every spring I set up a stepladder and camera in our yard and captured pictures of the male Black-chinned Hummingbird—this the first photo of the 2015 season.

44 This is the adult Western Screech-Owl and parent of the chicks on page 5, a little fluff from a Cottonwood tree to the right.

45 The formally endangered Trumpeter Swan has been considered a classic conservation success. These cygnets at the Montana Waterfowl Foundation were later released to the wild.

46 This famous Peale's Peregrine Falcon, called W/Z, was banded by Coastal Raptors at Ocean Shores, Washington, in November of 2007 as a youngster. This photo was taken in 2013.

47 Three-week-old eagle chicks were fed little strips of fish by the female. Most of the food deliveries by the male, however, had been Columbian Ground Squirrels.

48 I photographed Cliff Swallows from the second floor over the garage using manual focus and just hitting the shutter when I thought they were in range.

49 An Eastern Kingbird was especially annoyed this summer day by an Osprey flying back and forth to his nest.

50 A female Snowy Owl on the Washington coast. Made popular by the Harry Potter series, these birds were at the top of every kid's Christmas gift list for a while.

51 Sibley the Peregrine caught this Mallard drake in the air right over a slough and wouldn't let go as he tried to escape underwater.

52 An American Dipper was foraging, diving underwater and bobbing up and down on rocks as it searched for aquatic insect larvae.

53 A Bald Eagle stretches, extending one leg and then the wing on that same side.

54 A resident Pileated Woodpecker often pounds on our utility pole, the resonating racket marking its territory. Here the female touches her tongue to the frozen wires in winter.

55 A Calliope Hummingbird was captured at a camera shutter speed of 1/5000th of a second, the wings in flight a blur otherwise, rotating in circles at the shoulder in a figure eight.

56 Spotted Sandpipers race around on the beach all summer on an insect quest, their call a piercing *weet*.

57 Lewis's Woodpeckers use the hunting tactic of flying off treetops to catch insects in the air like a flycatcher. This nestling was fed some berries instead.

58 A young Great Horned Owl from a subterranean nest in the foundation of an old building made an appearance, flying to a tree and returning after I had departed.

59 American Robins are perhaps the first bird any child learns to identify, and this one was catching insects in the air over the river in late summer.

60 I observe the eagles on the Bitterroot River behind our house from a raised portion of the riverbank 100 yards away from the nest; this nest first fledged two young here in 2012.

61 I noticed a White-tailed Deer running behind this pair of Sandhill Cranes at nearby Lee Metcalf National Wildlife Refuge, right down the road.

62 A heron and egret rookery (Snowy Egret here) is located between two lanes of traffic going either way at a condominium development in Santa Rosa, California.

63 Ospreys nests are added to every year, becoming gargantuan structures after several years. This one was on the top of a huge metal power tower.

64 A Red-naped Sapsucker pounded on a tiny dead tree in the yard, extracting insects. The tree is the favorite perch of the hummingbirds all summer.

65 Northern Goshawks are skilled at catching birds and mammals; this adult male targeted our homing pigeon loft in December.

66 Exactly one month after leaving the nest the three Bald Eagles know how to fly but are not that skilled at landing. This one actually broke limbs off the snag as she tumbled down.

67 The beautiful iridescent throat feathers on male hummingbirds are called gorgets, and this Calliope displayed his beautiful plumage in the sun.

68 The vocalization of a Great Blue Heron may bring to mind the sound a pterodactyl might have made: croaking, hoarse, and scary.

69 A Black-crowned Night Heron added to his nest in April.

70 "A startled expression" and youngster with a "frown" characterize the Great Gray Owl, in the words of Hans Peeters in his superb book *Owls of California and the West*.

71 The resident pair of kestrels usually harassed the Bald Eagles, but here the male eagle claimed a favorite perching spot by size alone.

72 Named a Great Egret for many reasons, this one was in California, the nice weather casting shadows in the white plumage.

73 Wild Turkeys have experienced a population explosion in many places in western Montana, fed by some, hunted by others, but a common sight in certain locales.

74 Big West Coast shorebirds, Black Oystercatchers were carrying on at Morro Rock in California. These three stuck to themselves, ignoring the other avian beach inhabitants.

75 A young Rufous Hummingbird was stationed on the fence for days, exactly in between two feeders, as if unable to decide which one to frequent.

76 I used this line on the PBS television show *BirdWatch* many years ago, with host Dr. Dick Hutto, my zoology advisor at the University of Montana starting in 1978.

77 The Yellow-headed Blackbird cutting loose in song in the spring is certainly one of the strangest sounds in the marsh.

78 Cedar Waxwings were busy in courtship. The red "wax" on their wings is really just a pigmented extension on their secondary feathers, barely visible and not much of a field mark.

79 This Sandhill Crane was intent on catching whatever was in the grass at his feet, which could have been anything from insects to worms, mice to bird eggs.

80 After the young had fledged, the male Pileated Woodpecker retreated back into the nest cavity right at dark, even in the winter, just like clockwork.

81 A dear friend Barry Gordon always asks, "How many Bald Eagle pictures do you need?" The answer for 2015 was 3,575 photos, thousands more deleted!

82 This male Osprey was soaking in the late July sun, a rare moment of relaxation with no Bald Eagles around to dive-bomb.

83 A male Harlequin Duck was tucked away out of the high winds of Morro Rock, inconspicuous even with his brilliant plumage.

84 Great Gray Owls look huge when seen in their habitat, but these owls are mostly feathers with giant bulls-eyes on their faces. Great Horned Owls outweigh them.

85 People constantly refer to this species as Canadian Goose, and we always point out that we don't really know where they were born. Canada Goose is correct.

86 This young Great Blue Heron was usually hanging out at the pond behind the house in the evenings. What a find—the heron, a female Hooded Merganser, and a White-tailed Deer.

87 This August evening, two of the Bald Eagle youngsters were racing up and down river in play, with an Osprey attacking the third in the light rain and high winds.

88 A young Northern Harrier was hunting low over some marshes in our valley, so buoyant and acrobatic in the air.

89 A young Peregrine Falcon has had enough of a pesky raven; interactions between the species were constant until the falcons migrated in late September. Common Ravens remain all year.

90 In August, an Osprey routinely caught fish and headed south for a delivery to his nest, sometimes returning within minutes to continue hunting.

91 These Sharp-tailed Grouse displayed on a "lek" in central Montana. Mating dances were cut short in a hurry when a Prairie Falcon flew overhead.

92 Tree Swallows love nesting boxes, and we a dozen on our property. This male posed on the fence wire after feeding the chicks.

93 On the 4th of July the eagles had been out of the nest for exactly a week when another newly fledged bird showed up, a Great Blue Heron.

94 A pair of Prairie Falcons had nested nearby years earlier; a female was investigating a few rocky caves in March, flying in and out and eventually choosing a different nesting location.

95 A male Hooded Merganser is beautiful in full breeding regalia, the crest of feathers erected to impress the females. I know I was impressed!

96 These American Kestrels returned time and time again to the safety of the cottonwood cavity nest after they had ventured out in their first flights.

97 The Bald Eagle pair was checking out an intruder during nesting season, the larger female on the left. There was no danger to them this time.

98 An Osprey caught several Mountain Whitefish, this one right in front of me at the river.

99 Northern Flickers are numerous, big woodpeckers with a bright malar cheek mark on the male. This one often dug around in anthills and ant colonies underground.

100 This Peregrine Falcon was seeking refuge from gale force winds in the dunes off the Washington beach, then flew out to chase some shorebirds in the surf and was gone.

101 Black-crowned Night Herons forage at dawn, at dusk, and at night, roosting in the day in dense foliage. It was a treat to see one out in the open.

102 A young Peregrine, one of three fledged falcons that were regulars on the beach in August and September, checked out a raven for a few seconds.

103 The young Bald Eagles stayed together for weeks after leaving the nest, fed by their parents and scavenging on the beach and elsewhere.

104 With their rattling call downriver, I heard these Sandhill Cranes long before I saw them and had time to set up for this landing shot.

105 The earliest we have found Peregrines returning to Montana from migration is Valentines Day, and this was February 28th on the icy Blackfoot River.

106 At dark, a Killdeer was foraging on the riverbank with the reflection of autumn gold cottonwood leaves.

107 Tens of thousands of native trees have been planted at a nearby ranch, and a female Merlin was standing on top of this plastic protecting mesh.

108 A handsome Bewick's Wren posed in the California sunlight.

109 Bald Eagles steal fish from Ospreys in the spring, and it seems Ospreys get their revenge all fall by swooping on their arch enemies whenever possible, so not hilarity at all.

110 Lesser Yellowlegs are very vocal residents of the beach part of the year; here's another evening image with fall colors reflecting in the river waters.

111 Bobolink males have perhaps the most striking plumage in the wetlands and a bubbling song to match, plus they are the long-distance migration kings.

112 This young Osprey was quite adept at catching fish on our beach, lingering many weeks after his parents had migrated south in typical Osprey fashion.

113 I sometimes felt like a paparazzo, spying on the eagles nearly every evening for months at a time. They would occasionally notice me, but usually I was ignored.

114 In the spring, male Wild Turkeys have one thing on their minds and look buff as often as possible—strutting, raising their feathers and gobbling up a storm.

115 The spring floods of 2016 installed a new feature in the river behind the house, here a Spotted Sandpiper racing back and forth on the uprooted Cottonwood tree.

116 A pair of Hooded Mergansers preened their feathers for ten minutes before they noticed I was nearby hoping they would look up, and happy for the reflections in the water.

117 Sibley the Peregrine caught a duck over a little farm pond in October. This photo shows two birds, not a super-stretched falcon.

118 Appropriately the last photo, the male Bald Eagle was taking a drink at that same Cottonwood tree as the sandpiper just minutes later. What posers, and sure makes me happy.

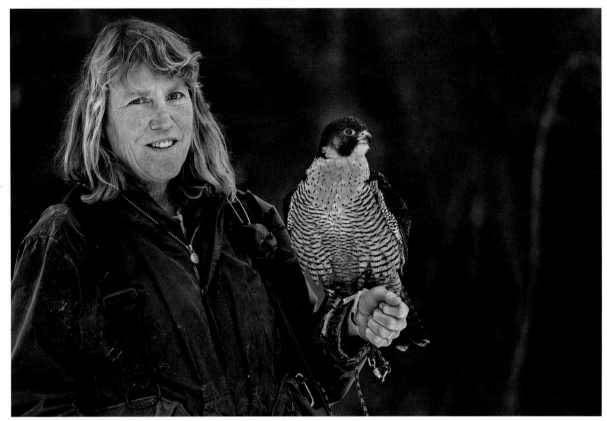

Surrounded by birds for the last 30 years, Kate Davis lives in an avian world. She founded the nonprofit education program Raptors of the Rockies in 1988 and keeps over a dozen birds of prey at facilities at her home in Western Montana. In this, her sixth book, she presents a different slant on a bird guide: a humorous and human look at our avian neighbors. Kate is a photography fanatic. For months out of the year she spends most evenings on the river behind her house, a bird mecca. Kate's motto: "Always have your camera ready. You never know what might fly by."

Web sites: raptorsoftherockies.com • raptorsoftherockies.org